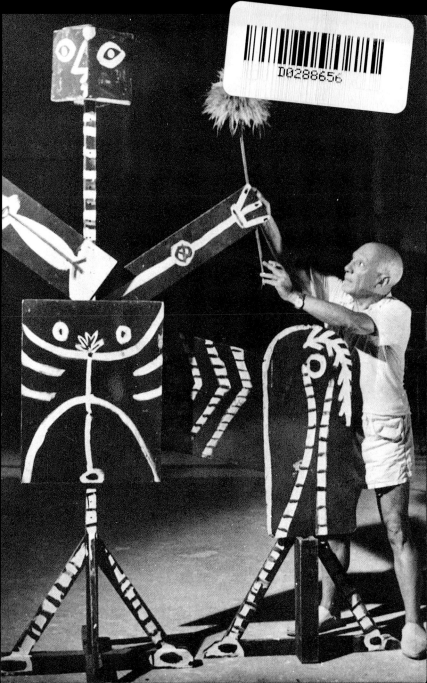

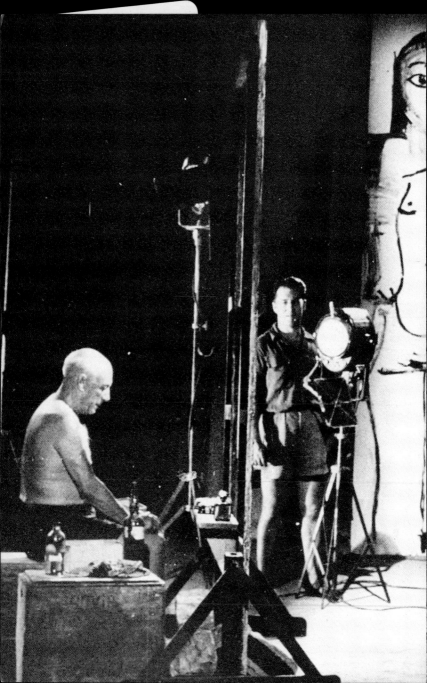

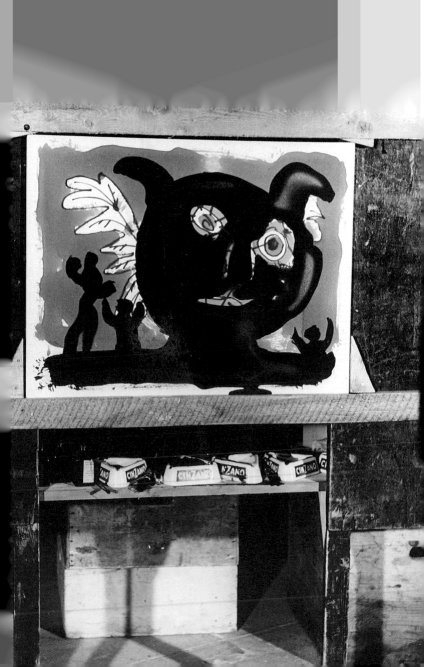

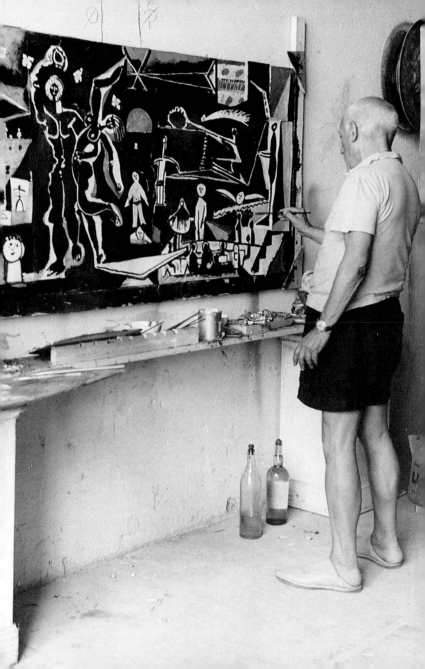

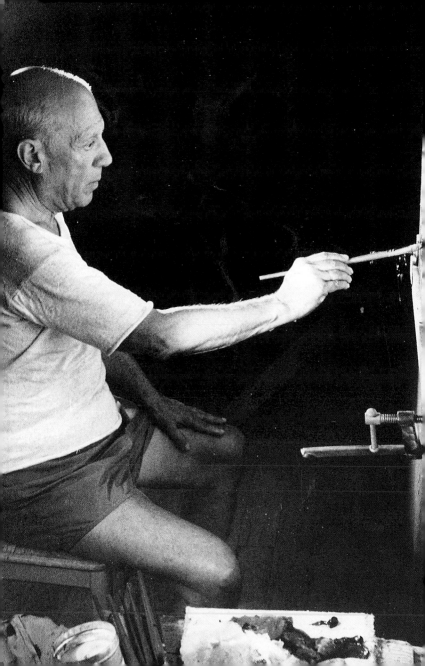

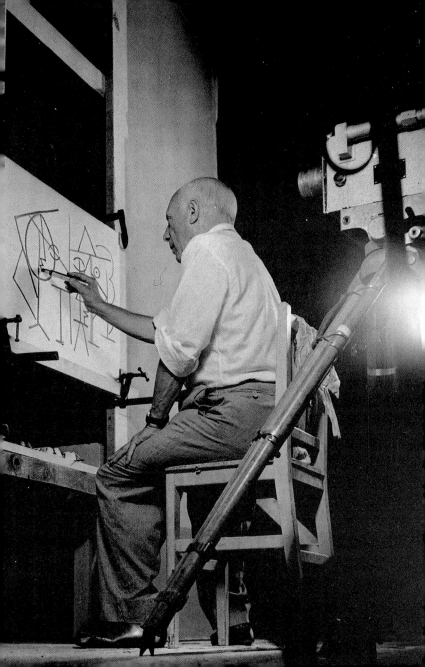

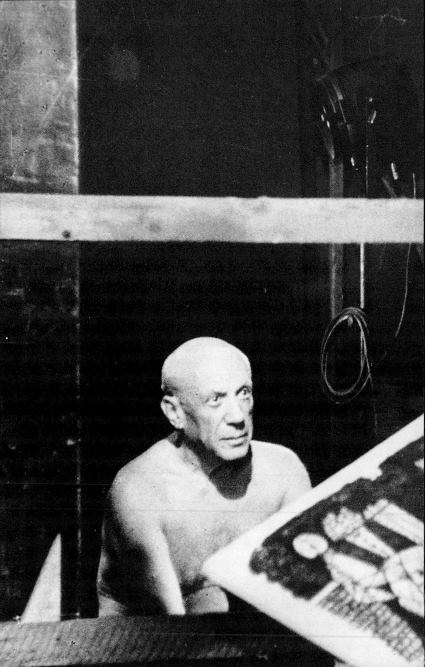

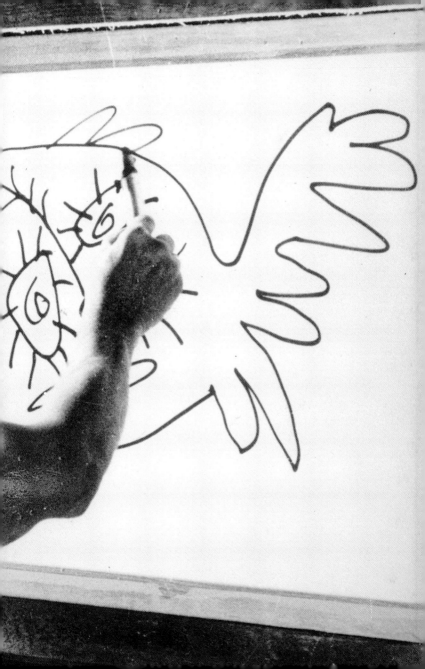

CONTENTS

PICASSO
MASTER OF THE NEW IDEA

Marie-Laure Bernadac
Paule du Bouchet

DISCOVERIES®
ABRAMS, NEW YORK

It was almost midnight—11:15 PM, to be exact—when Picasso was born in a big white house in Málaga, in the Andalusian region of southern Spain. That particular night, 25 October 1881, a peculiar combination of the moon and stars rendered the midnight sky especially luminous and cast an extraordinary white light over the slumbering houses.

CHAPTER I

A SPANISH CHILDHOOD

The Picador (opposite), an oil on wood, is the first known painting by Picasso, made when he was eight years old. He kept it throughout his life, even though it was slightly damaged. Picasso made this pastel portrait of his mother (left) in Barcelona when he was fourteen.

The small boy born under this strange light was named Pablo Ruiz y Picasso. Following Spanish tradition, he was given the last names of both his father, Ruiz, and his mother, Picasso. In fact, on his very solemn baptismal day in the nearby church of Santiago, he was given the names Pablo, Diego, José, Francisco de Paula, Juan Nepomuceno, María de los Remedios, and Cipriano de la Santisima Trinidad. To give a child multiple names was a regional custom—perhaps Málagans believed the child would thus receive many gifts.

Both Pablo's parents were Spanish. His mother, María Picasso Lopez, was Andalusian to the roots of her hair, which was so black it was almost blue. His father, José Ruiz Blasco, was himself also Andalusian—but to the other extreme: He was tall, thin, red-headed, and fair. The two sprang from the fabric of contradictions of which the Spanish seem to be made. Along with these parents came an immense, bustling family whose members were as diverse as stones in an old wall: priests and artists, teachers, judges, minor functionaries, and penniless aristocrats. Picasso would embody all his fiery ancestors. Truly all Spain would be in him.

Pablo's First Drawings

Don José, Pablo's father, was a painter. His favorite motifs were invariably composed of plumage, foliage, parrots, lilacs—and, above all, pigeons. The Plaza de la Merced, where the Ruiz family had its home, was shaded by plane trees in which nested thousands upon thousands of pigeons. Don José populated his canvases with the birds, arranging them harmoniously in his compositions.

Pigeons were thus among the first companions of little Pablo. He might not have been able yet to walk or talk, but he could see. He watched things with an attention so intense that it finally made him speak his first syllable: "Piz! Piz!" It was not a word, so much as an order:

Below: Some of Pablo's first drawings of pigeons, executed at age nine. Son was copying father: Don José made many paintings of birds, and, to provide himself with models, he raised doves and pigeons, which flew freely about the house. Picasso would have a sentimental attachment to these birds all his life.

"Lapiz!" (Pencil!) He wanted to be like his father and draw the pigeons he saw in the trees.

Indeed, Pablo was able to say "pencil" before he could fetch a pencil himself. He was able to draw before he could speak, and he could speak long before he was able to walk. "I learned to walk by pushing a tin of Olibet biscuits," he later said—a square box, closed, a cube. Tiny Pablo, still some ways away from being the inventor of Cubism, knew perfectly well what was in the cube.

Some years later, Don José, already amazed at the artistic talents of his son, began to surrender his paintbrushes to him. He started by letting him paint the pigeons' feet on his canvases. One evening Don José left his son a huge still life to complete. Upon his return, he found the pigeons perfectly finished, their legs so lifelike that Don José, deeply moved, brusquely handed Pablo his brushes, palette, and paints, telling himself that the talent of his son was greater than his own and that from that point on he would no longer make art.

There is more to this passing-on of paintbrushes from father to son than meets the eye. It is reminiscent of another kind of ritual with which all Spanish boys were familiar: the moment when the apprentice bullfighter becomes a true matador, capable of killing his *toro*. Pablo had been acquainted with bullfighting almost as long as he had with pigeons: Don José had taken him to see bullfights since the time he was very young. They shared an enthusiasm for the dazzling, vibrant bullfighting ring, for the wild, fuming bull, for the blood, which assumed an extraordinary color against the velvety blackness of the animal, for the shouted "Olé!"s, for the onlookers' fans,

This painting is a work by Don José Ruiz Blasco, who, during the 1890s, was named curator of the Málaga museum. (In fact, he never "curated" anything; for lack of financing, the museum never got off the drawing board.) Careful, reserved, discreet, Don José painted very realistic works that Picasso would later describe as "paintings for dining rooms."

which sometimes made the crowd appear to have sprouted wings, and for the arched body of the toreador in the light.

The Great Treasures of Spanish Painting

In 1891 Don José accepted a post as professor of drawing in La Coruña, in the very north of Spain on the west coast, and the family made ready to move. In addition to Pablo, the family now included two little girls, Lola and Concepción. In La Coruña, the weather was gray. The Atlantic Ocean was cold and sometimes produced such dense fog and rain that all light was extinguished. As soon as he saw La Coruña, Don José knew he hated this city. To make things worse, barely a few months after the family's arrival, little Concepción contracted diphtheria and died. This made the city completely odious to Don José.

For Pablo, the move had just the opposite effect. The family lived just across the street from the art school where his father worked, and Pablo had only to cross the street to be able to try out all the drawing and painting techniques his father taught his students. Pablo quickly mastered shading and modeling with charcoal, which enabled him to give his line drawings a more three-dimensional quality.

But at his own elementary school, he learned nothing: At the age of eleven, even the most rudimentary skills, such as

T his photograph of Picasso (left) was taken in 1896, shortly after his arrival in Barcelona. His closely cropped hair accentuates the intensity of his gaze.

T*he Young Girl with Bare Feet* (1895, below). Picasso painted this portrait in La Coruña. "Poor girls in our area always went around barefoot, and this one had feet covered with chilblains," he said. The treatment here is realistic and traditional, but one can already sense the maturity of an artist who knows how to convey the gravity of an expression, the sadness in a pose.

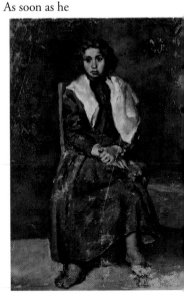

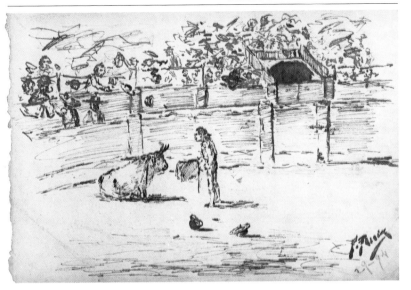

reading, writing, and arithmetic, were difficult for him.
On the day Pablo had to take the final examination for his
diploma he was forced to tell the examiner that he knew
nothing. But the kindly, understanding gentleman drew
columns of numbers on the blackboard for Pablo to write
on his paper, and asked him, gently, at least to copy them.
That, Pablo knew how to do! He copied them perfectly;
they were even prettier than those done by the examiner.
Pablo was happy. He thought of his parents' pride, but
perhaps he thought more of the paintbrush he would be
given as a reward.

Next, however, it was necessary to do the addition, to
draw a bar and put something underneath! Luckily, the
teacher had written the total on his blotting paper, and
Pablo simply copied the figures, even though to him they
were upside down. He would always be very good at
that—years later he would sketch the faces of his friends
seated across the table from him, upside down so that the
drawing faced his companion. In any case, that day Pablo
returned home triumphantly, his diploma under his arm.

While walking he calculated the manner in which he
would paint the whole pigeon that his father would

The Bullring, 1894.
Picasso's childhood
drawings frequently
depict corridas, his
favorite entertainment.
He began attending them
at the age of five or six,
sitting on his father's lap
so that they would have
to pay for only a single
seat. Throughout his life
Picasso would remain
passionate about
bullfights, which he went
to see each year and
which reappear
constantly in his work.

perhaps at last let him do. "The eye of the pigeon is round, like a zero. Under the zero, a six; beneath that, a three. There are two eyes, and two wings as well. The two feet stand on the table, perched on the addition bar. The result is underneath." However, for Pablo, the important result was not an arithmetic sum but the canvas he would soon paint.

At the beginning of the summer of 1895, the Ruiz family packed up and left to spend the holiday in Málaga. On the way they stopped in Madrid, where Don José took his son to see the paintings in the Prado. They were dazzling: works by Diego Velázquez (1599–1660), Francisco de Zurbarán (1598–1664), Francisco de Goya (1746–1828). Pablo encountered the treasures of the Spanish masters for the first time.

Pablo Picasso: Boy Prodigy

At the beginning of the 1895–6 school year, the Ruiz family left to travel north for the second time. But this time they went to Barcelona, where Don José had just been named professor of drawing at the Academy of Fine Arts, known as La Lonja. Barcelona, capital of the region of Catalonia, was a large city full of history. Nestled in the northeast corner of Spain, it was rich in Spanish culture but had also always been open to the rest of Europe and its influences.

For several decades there had been a powerful artistic and cultural current running between Barcelona and France: Barcelona society was permeated with the French, and a good number of Catalan intellectuals had moved to Paris.

Pablo liked Barcelona right away. It was not La Coruña, the town that seemed permanently imbued with gray. Nor was it Málaga, superb and solitary on its rock. It was a true city teeming with life, rich and bountiful, colorful and free, and full of all sorts of people. For Pablo, Barcelona opened the door to life.

La Lonja was an old academy with rigid rules: One mainly studied the classics, endlessly copying from plaster casts of ancient Greek and Roman statues. Pablo had just turned fourteen. In theory he was too young to

be admitted to the school. But on the insistence of his father, he was allowed to take the entrance examination. "Classics, Nature, Life Modeling, Painting": That was the program for the examination. When Pablo took the test, the jury was stupefied: In one day the child finished the exercises for which the rest of the students were given an entire month. And he did them with such mastery, with such precision, that no member of the jury hesitated to call the boy a prodigy.

In his first courses at La Lonja, Pablo forged a friendship with another student, Manuel Pallarès, that would come to teach him more than the tedious classes at school; Pablo spent much more time in his studio in the Calle de la Plata doing portraits of his friend and talking for hours about their work than he did in the halls of La Lonja.

Pablo Discovered the Wild Catalan Countryside

The Ruiz family returned to Málaga for the summer of 1897. Don José, at least, was happy to be home again. But Pablo was sixteen and already had the acute sense that he needed to escape from certain influences that he found too stifling: school, and its academicism, and his own father, who stopped by the studio a bit too often.

At the beginning of October, Pablo left Málaga for Madrid. He sat for the entrance examination at the Royal Academy of San Fernando—a success as brilliant as in Barcelona! In a single day, he executed a series of extraordinary drawings. At sixteen, Picasso had already passed

Opposite: *Academic Study of a Cast of a Classical Sculpture,* 1893–4. At La Lonja in Barcelona, Picasso received a classical training, copying from ancient plaster casts. The perfection of his drawings stunned his professors. "I never made children's drawings; at twelve I drew like Raphael…." The two self-portraits below are part of a series of studies done between 1897 and 1899. Picasso here casts himself in the image of the bohemian artist that he was at the time: black hat, shabby dress, unruly forelock.

all the tests of the schools of fine art in Spain.

It was the second time that he found himself in Madrid, but this time he was alone and without money. He found a minuscule apartment in the center of town and immediately started to paint. Without wood to warm himself, without fire—and it was winter—without much to put on the table, he worked unceasingly, impassioned by his new independence. He worked too hard and ate too little, and the harsh winter was very long; by spring, Pablo had fallen gravely ill with scarlet fever. He returned to his parents in Barcelona.

Summer 1898. Pablo's friend Manuel Pallarès invited him to come recuperate in his parents' village, Horta (Garden) de San Juan, in the wild region called the Ebro. It was the first time that Pablo had ever stayed in the country. When the heat became intolerable, Pablo and Manuel hiked up high on the mountain and set up camp in a cave, buying their food from a farmer. There on the mountain, in the cool shade, they spent entire days painting. But summer ended, and with it the sojourn in Horta. His stay in the country, however, left a strong impression on Pablo. Many years later he would say, "All that I know, I learned in Pallarès's village."

In spring of the following year, Pablo had a crucial encounter in Barcelona: He met Jaime Sabartés, a young poet who would prove his most faithful friend.

Picasso Had His First Exhibition

Two years earlier, an artistic and literary tavern called Els Quatre Gats (The Four Cats) had opened in Barcelona. The owner, enamored of Paris, had given it this name in memory of Le Chat Noir, a famous cabaret in Montmartre. The tavern stood only a few steps away from the so-called Chinatown of Barcelona, a carefree but sordid neighborhood where artists, political rebels, poets, and vagabonds gathered at night. Nothing was less Chinese, nothing more Spanish, than this Chinatown, with its winding, teeming streets, its smoky bars— where, under the low vaults, resonated the deep voices of flamenco singers—its gloomy cabarets that opened after midnight, its guitars with their sharp, hot, punctuated notes, its music halls, and its streetwalkers.

At the turn of the century, Barcelona was one of the cradles of intellectual life in Europe. There, *modernismo* was celebrated in a flowering of publications such as *Pél y Ploma (Brush and Pen)*, *Joventut (Youth)*, *Catalunya Artistica (Catalan Art)*, and *Arte Joven (Young Art)*, of which Picasso himself was art director in 1901. These same journals were also a means of expression for the anarchist movement, which was solidly implanted in Barcelona. Barcelona, according to one contemporary account, "was the the capital of anarchy, the spot where the anarchist forces, then growing throughout Europe, would begin to have an indisputable preponderance in the heart of the working class." The dreadful misery that reigned in the underprivileged sectors of the city contributed to a climate of social violence that frequently took the form of riots and attacks.

It was at Els Quatre Gats that, on 1 February 1900, Picasso exhibited for the first time: 150 drawings—mostly sketches of his artist, poet, and musician friends—were pinned up on the dirty, smoky walls.

Black hat, large tie, short jacket, dark shirt, and pants that narrowed at the ankles—this was the uniform of the brilliant, stormy troupe to be found nearly every day at Els Quatre Gats. Picasso, the youngest, very quickly became the group's leader, its star personality.

From the very first, some admired him and others detested him. Picasso's character was not an easy one—his moods were sometimes dark, sometimes light; he was alternately loudly carried away by his own opinions or taciturn and secretive about his deepest convictions; either closed somberly in upon himself or overflowing with a joie de vivre. Picasso's internal world was full of contrasts. Those who loved him loved him for this temperamental dichotomy. Those who detested him detested him for the same reason.

By the end of summer 1900, Pablo felt more and more strongly the need to break away from this milieu. He had to leave Barcelona. In October, with his new friend Carlos Casagemas, he took a train to Paris.

The celebrated café Els Quatre Gats owed its name to Le Chat Noir (The Black Cat) of Montmartre as much as it did to a Catalan expression, "Nobody here but us four cats." In 1899, Picasso designed a cover for the menu. Here he interprets with humor the style of turn-of-the-century English illustrators, while evoking the touch of Henri de Toulouse-Lautrec, a painter he admired.

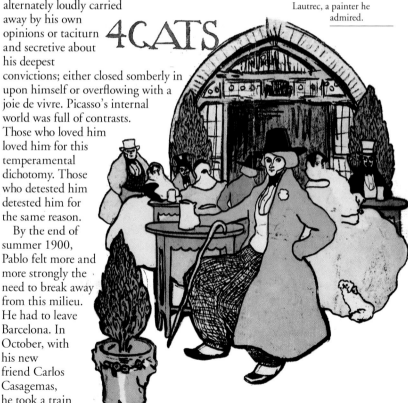

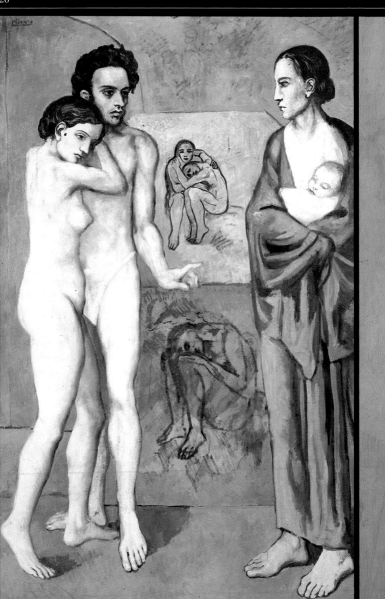

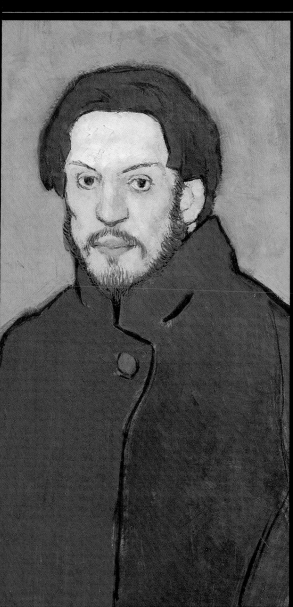

A Time for Color

The Blue Period (1901–4) canvases are among the best-known and, often, the most-loved of Picasso's work. No doubt this is because the figures represented appear to conform to reality; they most closely approach what one sees. The subjects of these canvases are easily recognizable, although they are Picasso's personal interpretations of images or emotions rather than faithful reproductions of reality.

La Vie (1903, opposite). This is one of the largest of the Blue Period paintings. To one side stands a nude couple, to the other, an emaciated mother—as if to say that life in its greatest moments, love and motherhood, is nothing but desolation. Between the couple and the mother are two sketches of nudes—reminding the viewer that creation is also present. For Picasso, creation—art—was life.

Self-Portrait (1901, left). In this portrait Picasso was only twenty, yet he appears considerably older—the hollow cheeks, thick beard, and wild eyes seem to express the loneliness and distress of a mature man.

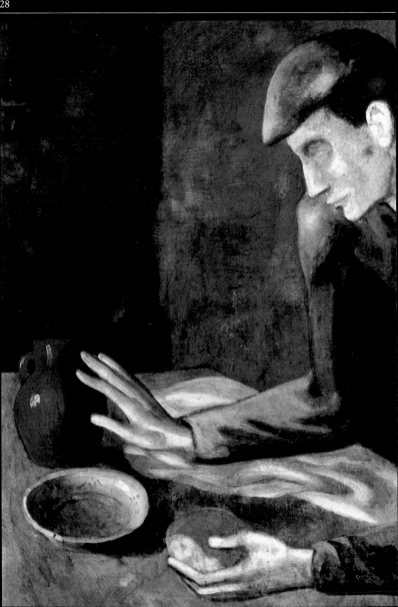

The Blue Period

Between 1901 and 1904, Picasso seems to have seen everything in blue, as if he had placed a colored filter between himself and the world. He chose blue deliberately: It expresses a feeling that is precise, particular. Blue is the color of the night, of the ocean, and of the sky. It is a deep, cold color that symbolizes pessimism and misery—as opposed to yellow or red, colors that express life, sun, and warmth.

The Blind Man's Meal, 1903. The theme of blindness obsessed Picasso during this period. The blind man in this painting lacks sight, but he does have the sense of touch: Hence, Picasso has given emphasis to his hands. For a painter, whose occupation depends on sight, whose entire power rests in the eyes, blindness is the worst of infirmities. Most of all, Picasso wanted to communicate through this theme that true sight is internal vision— what the artist sees and feels when he or she has understood that the external world is only appearance.

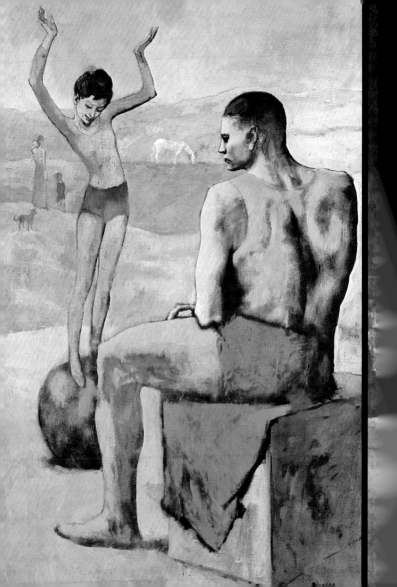

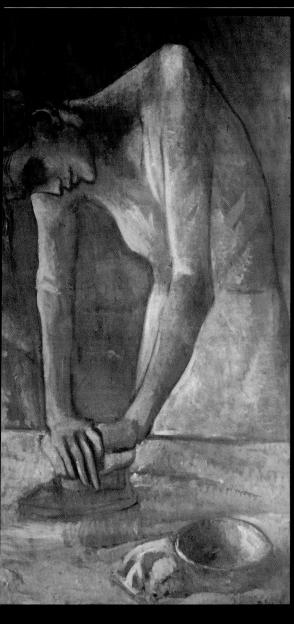

The Color of Dawn

The Rose Period, which lasted from 1904 to 1906, took its name from the ocher and pale pink that dominate these canvases—and also from the feelings of tenderness and fragility that emanate from the figures. Most often they are acrobats or harlequins, artists on the fringe whose gestures speak of vulnerability, grace, and humility.

Acrobat on a Ball (1905, opposite). An athlete whose large, muscled back is turned to us is seated on a cube. He watches a young woman standing on a ball. Her arms are raised in a charming gesture, and her arched body suggests a precarious equilibrium. The picture calls forth oppositions: On one side, strength, stability, mastery; on the other, lightness, agility, grace. Two geometric forms, the cube and the sphere, continue this opposition.

Woman Ironing (1904, left). A young woman leans wearily on her iron. Her body is thin, her face sad and tired. The subject matter of *Woman Ironing* remains that of the Blue Period (poverty, misery, effort), but the palette of colors has begun to lighten.

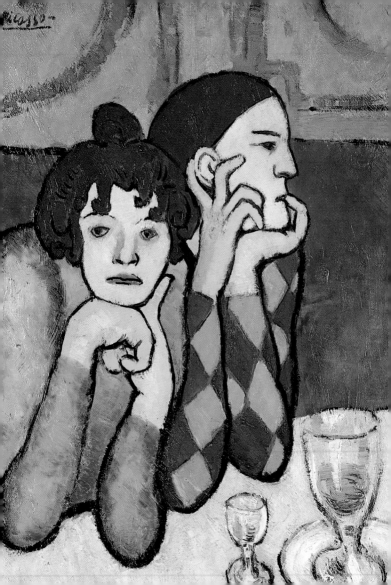

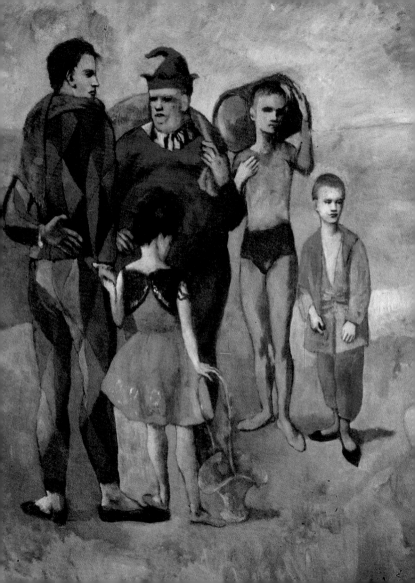

The Rose Period

In 1905 Picasso's life took a turn for the better. Every evening he went to the Medrano Circus, whose acrobats and charlatans fascinated him. He began to use them as models. He was interested more in their daily life than their performances. The harlequin with his checkerboard costume became one of Picasso's favorite themes.

Harlequin and His Companion (1901, far left) and Family of Saltimbanques (1905, left). These two pictures, made four years apart, depict the troupers that Picasso loved so. Wistful, a bit like sad clowns, perhaps slightly drunk, the harlequin and his companion daydream. Constant companions of Picasso during his Rose Period: the harlequin with his checkerboard costume, the old clown with his pointed cap, the two children, the acrobat wearing a loincloth, the dancer with her flower basket, a young boy, and a woman wearing a hat, seated in the corner. "But tell me," wrote German poet Rainer Maria Rilke (1875–1926), about this picture, "who are they, these acrobats, even a little more fleeting than we ourselves?"

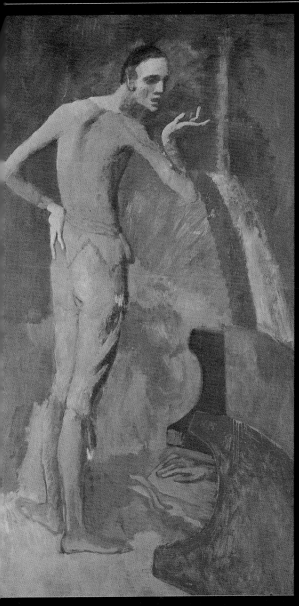

Harlequin Color

Left to right: *The Organ Grinder* (1905), *Acrobat's Family with Ape* (1905), and *The Actor* (1904).

"In Rome, at the time of Carnevale, there are masqueraders (Harlequin, Columbine, or *Cuoca Francese*) who, in the morning, after an orgy terminated perchance by a murder, go to Saint Peter's to kiss the worn-out toe of the prince of apostles. These are the beings who would enchant Picasso. Under the dazzling rags of these slender mountebanks one truly senses the young members of the people, versatile, crafty, adroit, poor, and lying."

Guillaume Apollinaire, *Picasso: Peintre et Dessinateur (Picasso: Painter and Designer)*, 1905

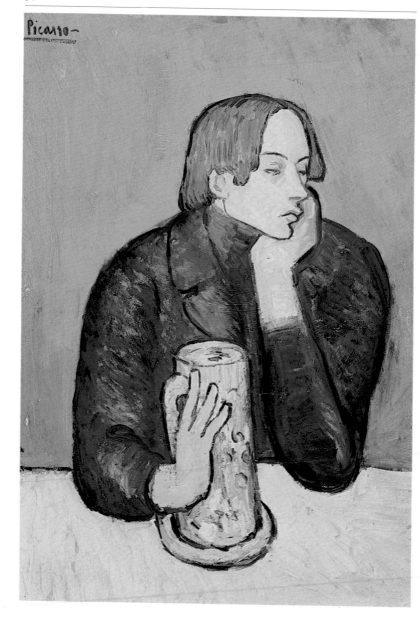

In 1900 Picasso turned nineteen. His trip to Paris was his first adventure in a foreign country. Immediately upon his arrival in the city, Picasso settled in Montmartre, the district that exuded the greatest glamour. At the time Picasso did not speak a word of French, but it was autumn, a glorious autumn, and Paris was in its prime. Picasso was enraptured.

CHAPTER II

MAD YEARS IN MONTMARTRE

Portrait of Jaime Sabartés (1901, opposite). One evening Picasso's friend Sabartés was alone in a café; Picasso entered, spotted him, and made this portrait. The canvas is not entirely blue, but already a sadness is present. Right: *Self-Portrait,* 1902.

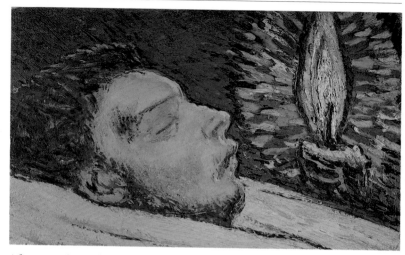

After several months, Picasso was acquainted with every single museum in Paris. He spent long hours in front of works by the Impressionists in the Musée du Luxembourg; in the Louvre, he discovered Jean-Auguste-Dominique Ingres (1780–1867) and Eugène Delacroix (1798–1863), and avidly studied 19th-century painters Edgar Degas, Henri de Toulouse-Lautrec, Vincent Van Gogh, and Paul Gauguin. Picasso was also fascinated by the art of the Phoenicians and Egyptians, at that time considered uninteresting and "barbarian." The Gothic sculpture in the Musée de Cluny amazed him. He loved Japanese prints. Everything interested him.

Nonetheless, several months later, for reasons that remain obscure, he was once again in Barcelona. He and Casagemas had returned to Spain. A Catalan publication hailed his return with an enthusiastic article, which ended with the exclamation, "His French artist friends have nicknamed him 'the little Goya'!"

But as these very lines were being printed, Picasso was already on his way back to Paris. A new era was opening before him, one that commenced tragically: Also having returned to Paris, his friend Casagemas killed himself because of an unsuccessful love affair.

The Death of Casagemas, 1901. The death of his friend Carlos Casagemas completely overwhelmed Picasso. He evoked this tragic event over the course of several canvases, which are among the strangest of this period. Here he painted from memory the face wan in death, illuminated by a candle—the overall effect reminiscent of the paintings of Van Gogh. The man's temple bears the mark left by the fatal bullet.

In Montmartre, Living by Night, Picasso Saw in Blue and Painted in Blue

Spring 1901. Picasso was almost twenty. A new era, a new return, a new address in Paris: 130 Boulevard de Clichy. At this address was a small room where the artist painted, ate, and slept. This was the "blue room," as seen in one of his paintings—blue, the color he loved, the way he saw things and the world during that particular period, blue like the clothes he wore. The color blue that Picasso once referred to as the "color of all colors." Thus began the era in his painting that is referred to as the Blue Period.

One day, during this time of midnight blue, there came a speck of dawn, a luminous encounter. In June, art dealer Ambroise Vollard held an exhibition of Picasso's canvases in his gallery. Among the visitors was an elegant young man, shabbily dressed in worn shoes but wearing an impeccable top hat. This noble-looking individual was Max Jacob, poet and art critic. Jacob was immediately struck by Picasso's paintings, and Picasso was charmed by Jacob—his fairness, the independence of his judgment, his impetuosity. A great friendship was born.

In the Cabarets of Montmartre Formed "la Bande Picasso"—Picasso's Crowd

Winter followed. Max Jacob entertained Picasso and his crowd, a group of young Spanish painters, in his small hotel room, smoky from pipe tobacco. They sat on the floor, keeping their coats on against the penetrating cold. Late into the night, they listened with great intensity to Jacob read his poems and those of other beloved poets, Arthur Rimbaud, Paul Verlaine, and Charles Baudelaire. The group frequented the cabarets of Montmartre—Le Chat Noir, sometimes even the Moulin Rouge. But that was rare, and the cafés that Picasso and his friends usually patronized were much more modest. For a time they met in a small cabaret in

Self-Portrait, 1901. In this sketch, made not long after his arrival in Paris, Picasso depicts himself all decked out and ready to work— an easel and palette under one arm, brushes sprouting from his pockets, a paintbox in his hand.

Montmartre called Le Zut. It was poorly lit and none too clean, but its low prices attracted all the penniless of the area. Picasso's group met there nightly in a room in the back where the owner, Fredé, served them himself.

In early January 1902, Picasso returned to Barcelona. He could manage to stay neither here nor there, loving one city with the same intensity as he did the other, needing Barcelona as much as he did Paris. Picasso's paintings during this time continued to be studies in blue; although the locale had changed, the figures and the tone remained the same. From Barcelona, he wrote letters to Max Jacob in bad French with a strong Spanish flavor, full of sketches of bullfights. In one letter, he depicted himself wearing his large black hat, his pants tight at the ankles, and carrying his cane. The letter began with excuses for not having written earlier; he said he had been working. "And when I don't work, well, then I amuse myself or I get bored." Picasso was ripe to cross the border again, and that is what he did in October 1902— for the third time in two years.

For Two Years Picasso and His Friend Max Jacob Shared the Same Hardships

In Paris at the beginning of winter 1902, Picasso endured poverty so extreme that Max Jacob invited him to share his room on the Boulevard Voltaire. Jacob had only slightly more money than Picasso; he had found work in a large department store but earned barely enough to pay for the room. There was only one bed, and a single top hat. The two friends had to share both! The bed was never empty: Jacob slept at night while Picasso worked, and, during the day, Jacob being at the department store, it was Picasso's turn to sleep. They did not have a penny to spare, and finding something to eat was a job in itself.

Still, Picasso loved his Parisian life and his friends. Six months later, once again in Barcelona, he wrote to Jacob with a touch of nostalgia: "My dear Max, I think about our room on the Boulevard Voltaire and about the omelettes, the beans, the Brie.…"

For Picasso, poverty was almost inextricably tied to creation. As his friend Sabartés wrote, "He believed Art to be the son of Sadness and Suffering. He believed that sadness lent itself to meditation and that suffering was fundamental to life. We were going through that age when everything is still yet to be done, that period of uncertainty that everyone considers from the point of view of their own misery."

1903–4. Picasso was in Paris, and then again in Barcelona. He never stopped moving, he never stayed still. In four years, 1900–4, he crossed the Pyrenees no fewer than eight times. But finally he bade good-bye to Spain. This time, in 1904, he moved to Paris for good.

The Bateau-Lavoir: The Center of Bohemian Life

Paris, 1904. The Bateau-Lavoir (Laundry Boat) was not a boat. Nor was it a washhouse—there was practically no running water, except for a minuscule and leaky faucet. Max Jacob had given it its nickname because it was connected to the street by means of a ramp, as if it were a boat. The Bateau-Lavoir was a strange, completely dilapidated building, a collection of damp, tortuous stairways that gave way onto dark corridors lit by dim bulbs. The walls were falling apart, and the doors opened onto rooms pretentiously called "studios." But, at this time, the beginning of the century, it was a mecca for artists in Paris. Picasso moved his studio there in the spring of 1904. He would stay five years.

The Bateau-Lavoir was dirty and uncomfortable. Yet an incredible mixture of people lived there—people with quite varied occupations: painters, sculptors, poets, cleaners, and street vendors. What they had in common was having not a penny to their names. There they lived a kind of life one might find in a village, people alternately arguing and helping each other out, gossiping, visiting, and becoming involved in tumultuous melodramas.

One day there was a violent storm, and a young woman rushed into the dark corridors of the Bateau-Lavoir to shelter herself from the torrential rain. Her long dark red hair was soaked, and her dress stuck to her legs. In her haste, she nearly bumped against a disheveled and swarthy young man. He stood blocking her way in the narrow hallway, with a small cat in his arms that he held out to her, laughing. The man was Pablo Picasso. The young woman was named Fernande Olivier. They were both twenty-two. Soon Fernande had moved into the studio. Pablo was very much in love, and

Fernande Olivier (above, in 1906), Picasso's companion from 1905 to 1912, would later describe her first vision of the painter: "Picasso, small, dark, stocky, worried, worrisome, with dark, deep, strange, almost staring eyes."

This photograph of the painter (opposite) was taken in 1904.

he painted her thousands and thousands of times. She would pose for hours, sometimes for entire days, in part because they were so poor she had no shoes in which she could venture outside the house. In the winter there was not enough money to buy coal. But they soon discovered a way to finagle credit: When the deliveryman knocked at the door, Fernande would cry out from inside, "Put everything on the floor, I can't open the door. I'm completely naked!"—thereby gaining a week in which to find the money.

Incredible Disorder Reigned in Picasso's Studio

The studio smelled of linseed oil and paraffin, materials that Picasso used not only for his lamp but also in his art (as a binder for his paints). Dozens of canvases were heaped against the wall, stacked on the floor, or leaning against the foot of the easel Picasso was working on. To the side of the easel were paints, brushes, and a collection of pots, rags, and aluminum boxes.

In addition to the many canvases there were books, a zinc tub, all sorts of bric-a-brac, white mice in a drawer, artificial flowers whose colors had appealed to him—an incredible disarray. But, according to the artist, a necessary one, indispensable in fact. Picasso lived his whole life in disorder. He found chaos to be a terrain that was especially rich and fertile for ideas and creation, a disorder that was in itself a kind of order. Things found their place through the necessity they had of being there at that particular moment. Imposed order, on the other hand, was something that froze his spirit.

Picasso also always needed solitude to work. But at the same time, he could not live without company. And, as he loved poetry, many of his friends were poets. In the autumn of 1904 he made the acquaintance of Wilhelm de Kostrowitzki, a brilliant, impetuous poet who was half Polish and half Italian, and who, having adopted France as his country, had changed his name: He was now called Guillaume Apollinaire.

Other poet friends included Alfred Jarry, Charles Vildrac, and, of course, Max Jacob. They often met in Picasso's studio. Jacob was an indefatigable entertainer. He read poetry beautifully and dazzled his listeners.

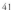

Portrait of Gertrude Stein, 1906. This celebrated portrait was begun in the winter of 1905. The famous American writer endured numerous sittings. In the spring, Picasso erased the face, with which he was not happy; in the autumn of 1906, upon his return from Gosol, he began again, giving it the character of a mask. The forehead is shiny, protruding, the lines impersonal, schematic, and regular. "It's the only portrait of me that will remain forever me," said its model.

Picasso Loved to Meet His Friends for a Meal or Extended Conversations in Cafés

At the Lapin Agile, a new café opened by the former owner of Le Zut, an excellent meal could be had for two francs. On the walls were artists' works that the owner had accepted in payment of their debts. Among these was one by Picasso that would one day become famous under the title *Lapin Agile.*

Picasso adored café conversations, either serious or rowdy. He loved unplanned encounters, on the street, in a restaurant, or inspired by a look—chance meetings that might turn into friendships. On the other hand, he hated people who asked him what he felt to be idiotic questions in their attempt to understand his work. This was clearly evident one evening when three young Germans asked him to explain his "aesthetic theories." Picasso took a revolver out of his pocket and fired three shots in the air! It was a joke, but he was the only one laughing.

Sculptor Paco Durio, painter Ricardo Canals, sculptor Manolo Hugué, and poet Max Jacob. These were his dear friends, Picasso's first true admirers. They were there almost every day, always ready to help him out. They would often leave with his drawings under their arms to try to sell them to get a little cash—Picasso himself refused to show his pictures to the public. At that time it was wrenching for him to see them leave his studio. And as for going to visit dealers himself, it was out of the question. He would rather give his work away than haggle about prices.

However, in addition to his poverty-stricken, bohemian friends, a few connoisseurs began to be enthusiastic about Picasso's canvases. Among them were two Americans, Leo and Gertrude Stein. On their first visit to Picasso's studio, they were so impressed that they immediately plunked down 800 francs for some paintings—an unheard-of event! And, in 1906, the dealer Ambroise Vollard himself also bought a large number of canvases, paying two thousand gold francs in a single stroke. Pablo and Fernande were finally able to splurge on a trip away from Paris. It had been two years since Picasso had left the city.

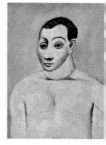

Self-Portrait, 1906. Picasso painted this portrait upon his return from Gosol, a sojourn that marks a profound break in his painting style. For the first time he painted what he saw without artifice, with a kind of crudeness, a purity of form. His figures took on a fullness that is almost sculptural. The works of this period also bear witness to the influence of Iberian sculpture. Picasso painted his own face as if it were a mask, almost as if it belonged to someone other than himself. The intensity, the almost savage archaism of this self-portrait shows the progression Picasso had made over the course of several years, even over the previous few months.

Spain, Sun, Cypress Trees

It was summer, and Pablo was seized by an irresistible longing for Spain. After this long sojourn that was so Parisian, so urban, Picasso needed the relaxation of the countryside. But he did not care for the French countryside, at least not yet. He said that it smelled of mushrooms. He needed the aromas of thyme and cypress, of olive oil and rosemary. The smell of the sun, the south, Spain.

At the beginning of June, he and Fernande bought two train tickets for Barcelona. From there they headed for a small village perched high in the Spanish Pyrenees. Gosol was a marvel of an ancient village, a dozen stone houses surrounding an empty town square, and it could only be reached on muleback.

In Gosol another life began. A life of excursions into the woods and climbs to the mountain peaks that one could see from the village, etched against the blue sky. For Picasso, it was another period of work. In Gosol he rediscovered a sense of calm and set about to paint with renewed ardor. As always, his subjects were people, landscapes, houses— everything he could see in front of his eyes. He painted the small, square houses with their unglazed windows, the peasant women with their scarves, the leathery faces of the old men, and, of course, the serene beauty of Fernande. At the end of the summer, Fernande and Pablo returned to Paris.

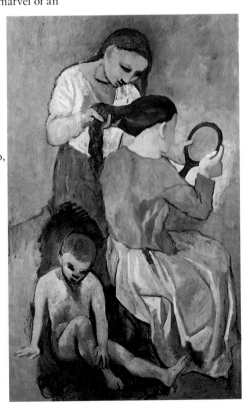

The Coiffure, 1905. This painting is characteristic of the Gosol period: round, simplified forms, oval faces, ocher and pink tones. The coiffure was one of Picasso's favorite themes during this period. He knew how to render the grace of feminine gestures, the serene and sensual atmosphere of such moments of intimacy.

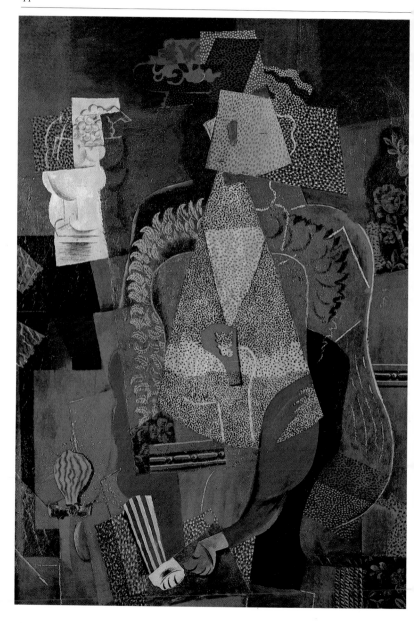

By the end of 1906, Picasso, at twenty-five, was recognized and admired not only in the domains of painting and drawing but also for his sculpture and graphics. Nonetheless, there soon would transpire an event that would turn Picasso, and all the seeming certainties of his work, virtually upside down.

CHAPTER III
THE CUBIST REVOLUTION

Portrait of a Girl, (Avignon, summer 1914, opposite). This whimsical, colorful picture imitates the effects of collage and wallpaper that Picasso was working with at the time. Right: Statue of a female, New Caledonia. Picasso had a wonderful collection of masks and primitive statues whose forms inspired his own work.

One summer day, in July 1907, Picasso went alone to the Musée de l'Homme, the Parisian ethnology museum. He was amazed by what he saw. The sculpture and masks of Africa particularly impressed him; to Picasso they seemed to hold a magical power. The clarity of connection between people and nature—a translation so vital, so immediate, full of the profound, ancestral feelings experienced by humankind—touched him directly. Picasso strove for this very immediacy in his painting. He had never wanted to "make art." Instead, he had been ceaselessly searching for that same transmutation (through painting, but also through other means) of deep feeling, inexpressible through the artifice of words alone; he believed it was also necessary to see and feel.

In African art he saw that kind of pure sensation and also a simplicity of form—a simple, straightforward geometry. Here was a new visual language with codified signs: a rectangle for the mouth, cylinders for the eyes, a hole for the nose, and so on. Picasso spent long hours in front of the museum's glass cases, returning several days in a row. The art of Africa and Oceania was a true revelation. What was to happen both within himself and in his painting would be forever marked by the experience.

Challenging, Provocative, Scandalous: Picasso's New Work, *Les Demoiselles d'Avignon*, Caused an Uproar

At the end of 1907, Picasso finished an immense painting begun several months before. The canvas was almost sixty-five square feet, and there had been hundreds of preparatory drawings. But, for the moment, nobody knew of these details. Picasso had shut himself up in his studio until it was finished. Absolutely everyone was forbidden to enter. Then, one day, he opened his studio door. Stupefaction, shock, consternation: No word is strong enough to convey the reaction of his friends. They had grown used to Picasso's painting, and had always been the first to defend it. But this time he had

Grebo mask (Ivory Coast). This mask o wood and plant fiber was found in Picasso's personal collection. Picasso spoke of African art as an "art of reason." By that he meant that artists represented not what they saw but what they thought, that they expressed ideas through forms. For Picasso, it was essential to understand the spirit of these masks, and this spirit can be found in a large number of his works.

gone too far. They disapproved categorically. The great painter Henri Matisse, to whom Picasso had recently been introduced by Leo and Gertrude Stein, was furious! Georges Braque, himself a new friend of Picasso's, told him, "It's as if you wanted us to eat [hemp] or drink paraffin!" Even Apollinaire, in the past so understanding, ferociously criticized Picasso. Furthermore, the day he visited Picasso, Apollinaire was accompanied by a well-known art critic who gently advised Picasso to devote himself to caricature instead.

There was a single exception to this concert of outraged cries: a young German collector named Daniel-Henry Kahnweiler. He liked the painting from his first visit, and he and Picasso soon forged a professional relationship as well as a lifelong friendship. Kahnweiler was to become one of the century's greatest art dealers.

This scandalous picture did not yet have a name, but it represented the first step toward one of the most important art movements of the 20th century: Cubism. Several years later, the painting would be named *Les Demoiselles d'Avignon.*

The uproar caused by *Les Demoiselles d'Avignon* did not deeply disturb either Picasso's work or his true friendships. Apollinaire and Max Jacob continued to come to the studio almost every day, as they had done before. At this time Picasso was working more regular hours: He painted less at night and more during the day, which allowed him both to have evening visitors and to go out more often. He and Fernande had even begun to venture across the Seine to the Left Bank. Every Tuesday they would leave Montmartre, all wrapped up in big overcoats that hung down to their feet, as the winter of 1907 was brutal, and travel to Montparnasse. In a restaurant called La Closerie des Lilas they met a new literary group that called itself Vers et Prose (Verse and Prose). The society included poets and writers, such as Paul Fort, Alfred Jarry, and Apollinaire, but also all their painter, sculptor, and musician friends. Picasso, like the others, loved these impassioned weekly discussions—intensified by strong drink—that often did not end until the group was thrown out with the first light of dawn.

Below: Georges Braque photographed at the Boulevard de Clichy studio in 1910. Braque and Picasso made a curious pair of extreme opposites. Braque was as stolid as Picasso was changeable, as sensible as Picasso was capricious, as retiring as Picasso was exuberant.

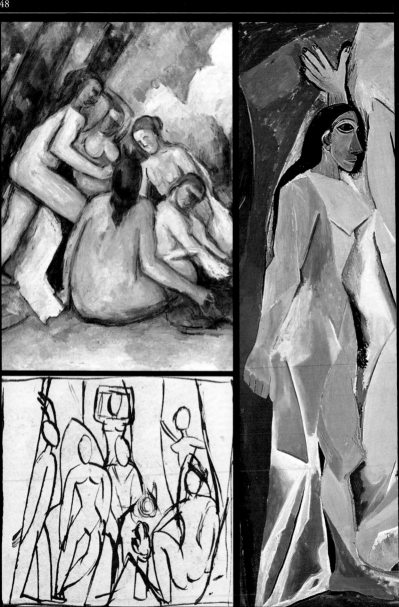

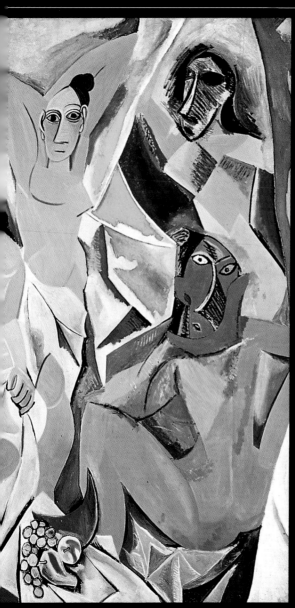

The Broken Bodies of the *Demoiselles*

Les Demoiselles
d'Avignon is
considered by many to
be the starting point of
modern art. Since the
Renaissance, the nude
had been a favored
subject for painters,
but here, for the first
time, a painter dared to
break with verisimilitude
and create a new
pictorial universe.

Opposite above:
Cézanne, at the
beginning of this century,
had painted this work,
The Large Bathers.

Opposite below:
Picasso rose to the
challenge. He worked
several months toward
the final painting,
studying its composition
in numerous sketches,
such as this one.

Left: *Les Demoiselles
d'Avignon*, 1907. One
can distinguish in this
painting two types of
female figures. The three
on the left have large,
heavily outlined eyes, ears
in a figure eight, and
noses seen in profile, even
if the face is seen straight
on. Picasso commented,
"The sideways nose, I did
that on purpose. I did it
that way so people will be
forced to see a nose." The
two figures on the right
are more angular, with
colored hatchings, and
their faces negate the laws
of symmetry.

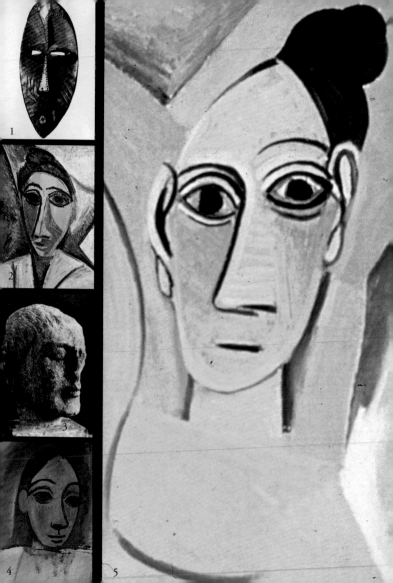

1

2

3

4

5

Mask Faces and Angular Appearances

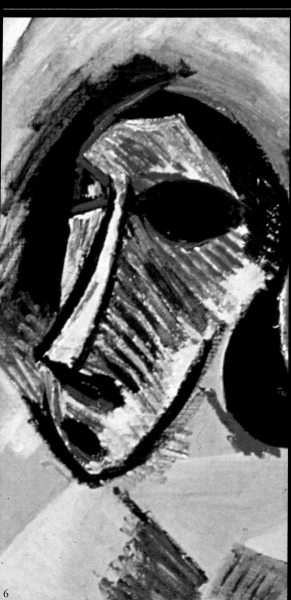

In an interview with the dealer Kahnweiler in 1933, Picasso declared: *"Les Demoiselles d'Avignon,* how that name gets on my nerves!… You know that at the beginning it was called *Le Bordel d'Avignon (Avignon Bordello)….* There should have been—according to my initial idea—men as well, and anyway you've seen the drawings. There was a student holding a skull. A sailor also. The women were eating, that's the reason for the basket of fruit, which remained…."

1. Mask from east-central Africa. Struck by the sculptural force and the magic power of this new form of art, Picasso linked the lessons of primitive art with the teachings of Cézanne.
2 and 4. *Head of a Sailor,* detail, and *Head of a Woman,* detail. These are two of the numerous studies Picasso executed.
3. Male head. Primitive Iberian sculpture, a period Picasso particularly admired.
5 and 6. *Les Demoiselles d'Avignon,* details. These two heads are very different. One displays a rounded, the other a striated face.

The Birth of Cubism

In the autumn of 1908, the painter Georges Braque entered six new canvases, all small landscapes, in the Salon d'Automne, an annual juried fall exhibition in Paris. The jury was completely nonplussed by this new approach. Color, instead of being the principal element, was muted. The emphasis was instead placed on simple geometric forms. Matisse, a member of the jury, observed what he called "les petits cubes."

Two pictures were rejected, and Braque, angered, immediately withdrew the others. Happily, the dealer Kahnweiler was not disturbed by this new style of painting, and he soon mounted in his own gallery an exhibition devoted to Braque. This was the first Cubist exhibition. At the same time, Picasso had begun painting figures and landscapes in the countryside not far from Paris using the same muted green and brown tones and the same simple, geometric forms.

The two painters soon began to work in close association. Both Picasso and Braque studied and admired the work of Cézanne, who had just died and to whom the Salon d'Automne had devoted a major exhibition in 1907. Close friends who inspired and supported one another, showed each other their work, and criticized and competed with one another, Picasso and Braque were—and for many years would remain—the leaders of and principal players in the Cubist movement.

Picasso Returned to Horta de San Juan in 1909, But His Vision of It Was Not the Same

In the summer Picasso had need of Spain as of a nourishing sap that rose with the approach of the hot season. Fernande and he left Paris for Horta de San Juan, his friend Pallarès's little village on the Ebro plateau where he had stayed eleven years earlier. It was that long since he had smelled the bitter, strong aroma of these plains devoured by the white-hot sun.

Horta was indeed the same village of earlier days, burning with heat, and it was the same landscape that it had been years earlier. But Picasso's vision had changed. The landscapes that he set on his canvas this time had

little do to with the ones he had made earlier. Now, instead of being satisfied with merely "copying" the landscape, he kept nothing of it but its underlying structure. He took any liberty he wanted, provided that it helped achieve his goal. The forms that Picasso saw became the glistening, hard-cut facets of a crystal or a gem. According to Cézanne, "You must see in nature the cylinder, the sphere, the cone."

Hardship Was Becoming a Distant Memory

Picasso came back from Horta with many canvases. Upon his return the dealer Ambroise Vollard organized an exhibition of his latest works. Despite the hostility of the general public toward the new Cubist approach, works sold—quite a lot of them. Picasso's admirers grew

Landscape with Two Figures, 1908. The two nudes in this landscape are completely integrated into the environment—the bodies blend into the trees. Landscape and figures are approached in the same manner, using simplified geometric volumes. As Cézanne said: "Painting is optical first of all. The material of our art is there, in what our eyes think." In 1908 Picasso was especially influenced by Cézanne.

considerably in number, particularly among the Russians, Germans, and Americans. He was far removed from the poverty in which he had lived barely three years earlier.

In September 1909 Pablo and Fernande left the Bateau-Lavoir. With their Siamese cat, they moved into a large studio/apartment on the Boulevard de Clichy. The windows of the apartment opened onto an ocean of green, and, in the studio, the light was sumptuous. There was a maid in a white apron, mahogany furniture, and a grand piano. The change in surroundings was radical, as was the change in lifestyle.

This did not prevent Picasso from bringing into his new palace the indescribable hodgepodge he required: guitars, bizarrely shaped bottles, a glass chosen for its intense blue, scraps of old carpet, paintings by artists he admired—Matisses, Rousseaus, Cézannes—and above all, a growing collection of African masks. At the very least, one might say that the styles mixed and clashed. It was Picasso's own jungle. He always said that he had a horror of good taste and harmony; he bought what pleased him without worrying about if it "went together."

For the summer of 1911, instead of returning to Spain, Pablo and Fernande stayed in the charming village of Céret, at the foot of the French Pyrenees. Shaded by enormous plane trees, with narrow, clean streets, Céret was full of peasants who came down from the mountain with their mules. In the middle of a field of apricot trees and grapevines, a friend had bought a delightful little monastery surrounded by a garden that was watered by a mountain stream. That summer Pablo and Fernande occupied the whole second floor. A group of artists and poets came that summer to Céret, and almost every evening the group would meet on the terraces of cafés, where they would talk for hours on end. When he was not conversing, Picasso was drawing on the marble tabletops.

Picasso loved Céret, its proximity to Spain, its young girls, the mountains that ran continuously along the horizon, the vegetation that mixed Mediterranean dryness and moist verdancy. Picasso would visit Céret several times, but never again with Fernande. In the autumn of 1911, Pablo and Fernande separated.

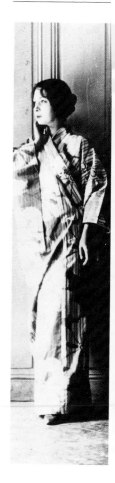

Eva (Marcelle Humbert) in Sorgues, north of Avignon, in 1912.

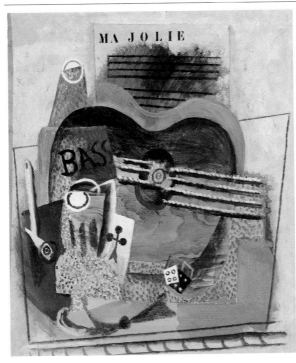

Ma Jolie, 1914. In this still life one finds the same bright colors and stippled and illusionistic effects as in *Portrait of a Girl*. At this time Picasso was infatuated with Eva, and a popular song of the day was titled "Ma Jolie" (My Pretty One). He included sheet music in his picture in order to sing his love through painting. He painted a number of still lifes composed of the most everyday objects, in particular those one might find on bistro tables—playing cards, bottles, pipes—and, of course, the guitar, whose shape recalls a woman's body.

Picasso Moved Away From Cubism and Met Eva

Eva's real name was Marcelle (Humbert), but Pablo called her Eva to tell the world that she had become first among women and that he loved her. In the spring of 1912, Picasso and Eva left Paris to nourish their love in the south of France. In Sorgues-sur-l'Ouvèze, six miles north of Avignon, Picasso rented a small, rather ugly villa called Les Clochettes. Braque and his wife, Marcelle, joined them there, having rented a nearby villa. Over the course of several months, the two painters lived through one of the richest and most fertile periods of Cubism.

Picasso had rediscovered his extraordinary passion for work. He was happy with Eva, and he wrote Kahnweiler, "I love her, and I write it on my paintings." And he did. "I love Eva" is inscribed on numerous Cubist canvases as a kind of signature, the way an infatuated lover carves the

name of the beloved on the bark of trees.

Les Clochettes was a little depressing, but inside
were beautiful white walls. Pablo was so tempted by this
expanse of white that he made some sketches directly
on the walls, and at the end of summer, painted a large
oval picture on one of them. As he was very attached to
his oval painting, he brought the stones of the walls
back to Paris—with the agreement of the landlord, of
course, who was compensated.

During the summer of 1912, Braque did a series
of charcoal drawings in which he included cutout
pieces of wallpaper. In a paint store, he had found
imitation-wood wallpaper that he glued onto the
drawing. A little later Picasso, full of enthusiasm,
adopted the same procedure. He wrote to Braque:
"I am using your latest paperistic and dustistic
processes." (Yes, Picasso wrote something like that.)
From that moment, the technique of papiers collés
(glued papers) spread like wildfire. But mainly, these
bits of cut paper allowed Braque and Picasso to
reintroduce color, which had practically disappeared
from Cubist canvases.

Cubism became the primary, most controversial
subject in art discussions. But Picasso deliberately
kept himself outside any kind of group activity. A year
earlier, in the summer of 1911, the first big Cubist
exhibition had been held at the Salon des Indépendants,
the group showing of artists excluded from the
conservative Salon d'Automne. Included were the
painters Robert Delaunay, Fernand Léger, and Marcel
Duchamp. Picasso, one of the inventors of Cubism,
was not among them.

The Beginning of World War I in 1914 Marked the End of Bohemian Life

Pablo and Eva moved to Montparnasse in the autumn of
1912. The Boulevard de Clichy and the bohemian life
were erased for good. The new studio was located on Rue
Schoelcher, a few feet away from Montparnasse and close
to the three cafés—Le Dôme, La Closerie des Lilas, and
La Coupole—where artists from all parts of the world
had just begun to gather.

Picasso in his studio in
the Rue Schoelcher in
1915. This photograph
was taken during the
bleak time when Eva was
ill and bedridden in a
hospital. Picasso traveled
by subway every day
from his studio to the
young woman's sickbed.

At the beginning of summer in 1914, Picasso and Eva were in Avignon. Braque was there too, along with the painter André Derain. The heat was stifling, the atmosphere heavy and tense. War was in the air. This immediate threat added to Picasso's depression, which had begun when his father died the year before.

On 3 August 1914, war was declared between France and Germany. The next day Braque and Derain left to join their regiments. Being a Spaniard, Picasso was not called for duty. He accompanied his friends onto the platform of the Avignon train station. He remained there, stranded, sad, and anxious. He sensed that in this farewell there was something more final than the simple departure of a train. The war broke out at a time when Cubism was in full flight, when extraordinary possibilities were on the verge of being realized.

Despondent, Picasso returned to Paris. But war had changed the city. Mobilization had dismantled groups of artists. The mood in Montparnasse had changed, too. Braque, Apollinaire, Derain, Léger—Picasso's closest friends had all gone. Throughout the war years, he would seldom see his friends who, only a short time earlier, had been so much a part of his daily life.

Max Jacob in 1915. Max was Picasso's oldest Parisian friend, and—during this time of great loneliness and depression brought on by the events of the war— one of the rare friends who had not gone to the front.

In the Middle of the Upheaval of War, Picasso Was Struck by the Loss of the One Dearest to Him

That winter, tragedy struck. Eva became sick and died of tuberculosis after terrible suffering. Picasso left the Rue Schoelcher. The atmosphere there was too sad, the memories too sharp. He moved to a small house on the outskirts of Paris, in Montrouge.

Before he moved, however, Picasso made the acquaintance of a poet on leave from the war, the brilliant and excitable Jean Cocteau. Cocteau adored Picasso's work and Cubism. As he was then associated with the Ballets Russes and its impresario, the great Sergey Diaghilev, Cocteau suggested to Picasso that he design the costumes and scenery for Diaghilev's next production, slated for the spring of 1917. Composer Erik Satie was to write the music. Picasso would have to travel to Rome, where the troupe was in residence. He accepted and left Paris in February 1917.

The Little Cubes of Cubism

The term "Cubism" was formulated for the first time by an art critic describing landscapes by Braque in which houses, trees, and background were all in the form of cubes. This innovation took place gradually. First came Analytic Cubism, the breaking apart and "analysis" of objects; then came Synthetic Cubism—collages, papiers collés, and constructions.

Still Life with Bread and Fruit Bowl, (1909, opposite and above left,. detail). In this painting all the objects are reduced to simple, geometric forms—cylinders, cones, spheres. Earlier, when a table was depicted frontally, the top of the table would not be visible. Here, however, Picasso painted it as if it were seen from slightly above, thus breaking all the laws of perspective.

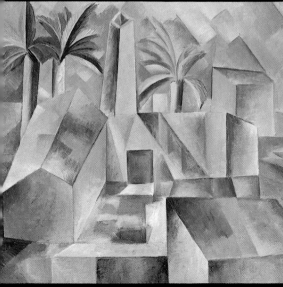

Factory at Horta de Ebro (1909, left). Here the surface is divided into facets, some light, some dark. The factory buildings are translated into cubes whose various faces overlap one another. Picasso treated the background objects in the same manner.

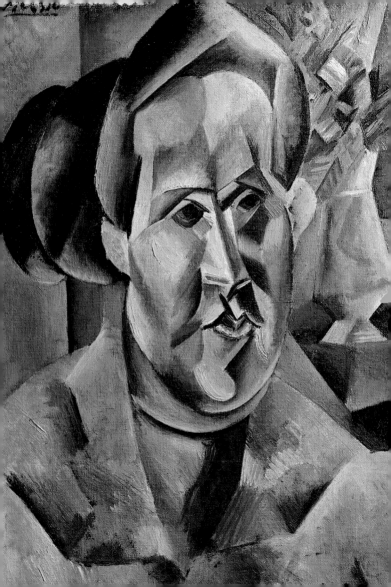

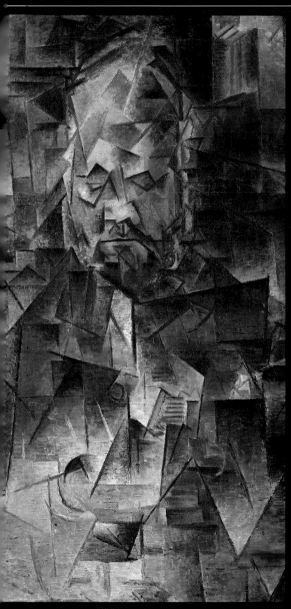

Shattered Faces

Cubist painters were concerned not only with an object's superficial appearance but with everything that was known about it: its sides, its profile, its position in space, and its relationship to other objects. How was all this included on a single canvas? By displaying simultaneously all aspects of the object, superimposing all views.

Portrait of Fernande (1909, opposite). The face seems fractured when viewed up close, but from a distance this experiment with planes allows the viewer to reconstruct the volumes of the forehead and the play of shadow and light.

Portrait of Vollard (1910, left). Beneath this tight latticework of planes, a man's face is still recognizable. The procedure that Picasso had used to deconstruct form was to lead him further and further. On the one hand, there was an intellectual process that followed the mechanism of the picture—an abstract matrix of features and facets. On the other was the actual model. The conflict was more and more pointed, tense: Was one obligated to preserve the model's appearance?

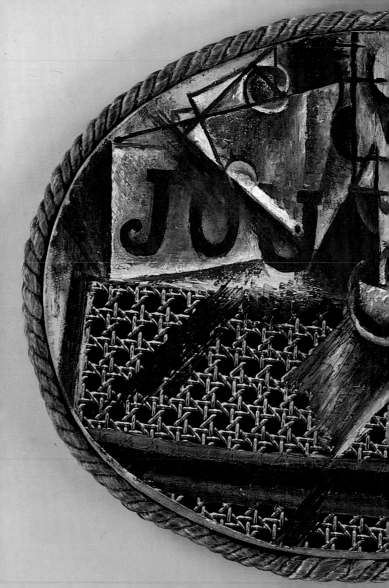

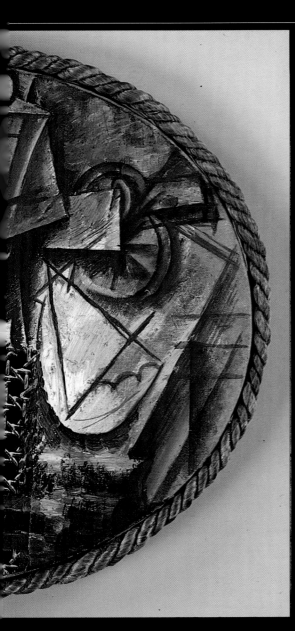

Rope, Newspaper, and Waxed Canvas: Collage

The new Cubist system was difficult for the uninitiated to understand. Braque and Picasso very quickly sensed the danger of Cubism's being transformed into a purely abstract aesthetic exercise reserved for a small number of initiates. To avoid this, they placed real elements in their canvases, material objects, to act as a sort of testament to reality. Braque started by introducing on one of his pictures a painted nail with its cast shadow, as if the nail affixed the canvas to the wall.

Still Life with Chair Caning, 1912. Rather than paint chair caning to give the illusion of a chair, Picasso took a piece of actual oilcloth printed to look like chair caning. He used real rope as a frame. Inside the picture are painted objects: to the right, a slice of lemon, a triangle with ridges representing a scallop shell, a transparent glass indicated only by summary lines. To the left are the letters "JOU." This half-word could refer to *journal* (newspaper), or *jouer* (play). The picture itself is a kind of game, a play of images.

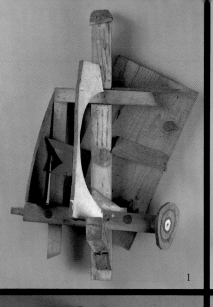

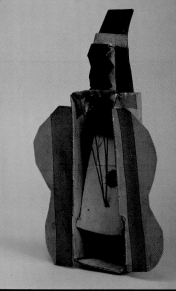

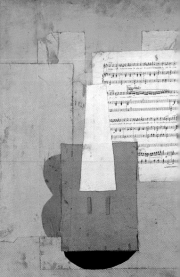

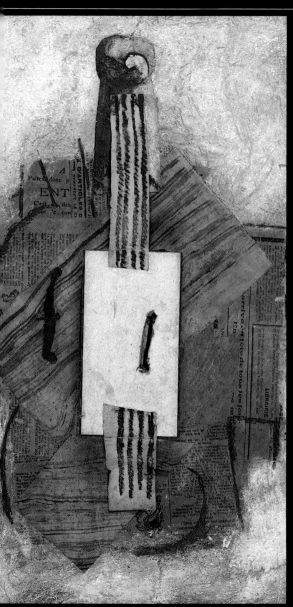

Papiers Collés and Constructions

After the seminal invention of collage, which opened up a realm of new materials to artists, Braque and Picasso began working with papiers collés. They took what they had at hand—newspaper, wallpaper, sheet music— and cut it up, pasted it, rearranged it. Papiers collés allowed them to reintroduce color, as well as to suggest a certain depth through the superimposition of different planes.

Opposite:
1. *Mandolin and Clarinet*, construction, 1913.
2. *Guitar*, construction, 1912.
3. *Violin*, construction, 1915.
4. *Violin and Sheet of Music*, papier collé, 1912.

The Violin, papier collé (1913, left). Picasso glued onto his canvas a cardboard box with a slit to indicate the body of the violin; the soundhole is drawn in a realistic manner to one side; the glued-paper imitation wood indicates that the violin is made of wood; the shape of the instrument is drawn in charcoal on newspaper; and the strings are marked on white paper. Thus, all the elements of the instrument are depicted using different techniques.

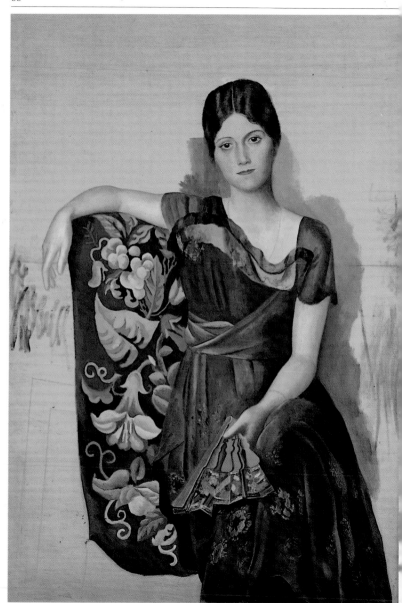

Rome and sunshine and the gaiety of the Romans. Rome, so grand by virtue of being so beautiful! The vaulted baroque monuments, marvelous churches, marble statues glistening in private chapels, the ancient Forum and Michelangelo and Raphael! Picasso, bedazzled, spent whole days walking, stopping in the cafés on the Via Veneto, and looking around him as if he had the thousand eyes of the peacock's tail.

CHAPTER IV
FAME ARRIVES

Portrait of Olga in an Armchair (Paris, 1917, opposite). In this painting Picasso showed a return to a classical, figurative style, but he chose to leave the painting unfinished: The armchair fabric is treated like a patch of papier collé.

Right: A study for a costume for the ballet *Pulcinella,* 1920.

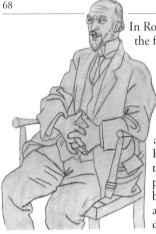

In Rome in 1917, Picasso felt the first rays of a new joy.

The stay in Rome also provided him with another surprise: He rediscovered the beauty of the human body. There were not only the ancient Greek and Roman statues, but also the marvelously agile, powerfully molded bodies of a troupe of astonishingly talented dancers. In the early 20th century, Sergey Diaghilev's troupe was without a doubt the most extraordinary group of classical dancers.

Diaghilev's new project, the ballet *Parade,* was daringly, resolutely modernistic: To combine the talents of Picasso, Cocteau, and Satie was to unite the artists at the cutting edge of the modern movement, putting all three at the service of dance.

Staged in Paris at the Théâtre du Châtelet on 17 May, *Parade* did not meet with a warm welcome. However, during the first performance, Apollinaire uttered for the first time a strange word in reference to the characters created by Picasso and Cocteau: "surreal." This word was destined to make its presence felt in the world.

Fascinated by the Dance, Picasso Also Fell in Love with Olga Kokhlova, One of the Dancers in Diaghilev's Company

Several months later, Diaghilev brought his entire troupe to Barcelona. Picasso went with them. Barcelona was still his city, and he was warmly welcomed by his old friends. His sister Lola had just married a doctor, Juan Vilato Gomez, and his mother was living with them. Picasso took a small room near the port and began again to paint. Strangely, what appeared on his canvases was very far from Cubism. These were traditional forms, objects that completely resembled the reality that served as the

Left above: *Portrait of Erik Satie,* 1920. At fifty-four, Satie, fifteen years Picasso's elder, was a personality whose manner was as eccentric as his music. Thanks to the efforts of his friends and fellow composers Claude Debussy and Maurice Ravel, he had recently become popular

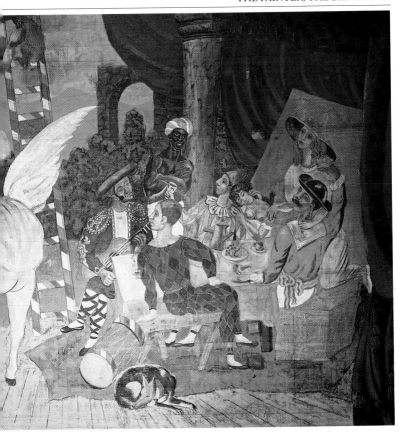

model. The most striking work of this new realist period was a portrait of Olga, into which Picasso poured all his emotions. It is an extraordinary portrait—a serious face, a Spanish fan, and a flowered armchair. Those who had seen in Picasso an enemy of classical beauty were obliged to recognize that they had been mistaken.

When the Ballets Russes left Barcelona for a tour through South America, Olga traveled with Pablo. They returned to Paris together in the autumn of 1917 and moved back into Pablo's small house in Montrouge. Olga spoke French fluently and adored Pablo's fantastical stories, which he told in his strong Spanish accent.

Above: Drop curtain for *Parade,* 1917. Beginning with its first performance, the public raged against the ballet. Lovers of romantic ballet detested it utterly. Picasso's curtain is now a museum piece.

On 12 July 1918 the two were married in a Russian church on the Rue Daru in Paris. The witnesses were Guillaume Apollinaire, Jean Cocteau, and Max Jacob. Shortly after their marriage, Olga and Pablo moved into an immense two-story apartment in the eighth arrondissement, a fashionable neighborhood where shops specializing in furs alternated with private mansions. Once again there had been a complete change in Picasso's environment. And again a complete change in lifestyle: Picasso now wore creased pants and carried a cane; three-piece suits hung in his closet.

Olga richly decorated the living and dining rooms, furnishing them with an impressive number of chairs to seat the numerous visitors she planned to invite. Picasso moved his studio to the upper floor. There he housed his jumble of objects, pictures, and the paintings he collected: Rousseaus, Matisses, Cézannes, and Renoirs.

With His Marriage, the Scenery of Picasso's Daily Life Changed

Now his friends were saying, "Picasso is spending time in *les beaux quartiers* [respectable neighborhoods]." Indeed, society began to cater to him. Showy receptions, suppers—the Picassos were showered with invitations. When they returned the favor, their new friends found nothing to fault them for in terms of service: Picasso functions were impeccably executed by a well-trained staff. This time, a change had been made for the better. Picasso's daily existence truly had been transformed.

Once ensconced in his beautiful surroundings, Picasso saw his old friends less frequently. Braque, back from the war, where he had received a serious head wound, was in delicate health and difficult humor. He disapproved of Picasso's new manner of living. It irritated him. Apollinaire, too, had come back gravely wounded. He had married in 1918 but, just when everyone believed he

A caricature of Jean Cocteau, Picasso's new friend, 1917 (left).

as on the road back to health, he died, victim of a severe ‹idemic of Spanish flu. He died on 11 November 1918, ‹e day of the Armistice, when the streets were draped with flags of victory and joy. That very day Picasso had been walking down the arcade of the Rue de Rivoli. Suddenly, as he passed through the crowd, a burst of wind carried off the black veil of a war widow and dropped it on his face. Seized by a dark foreboding, he hastily returned home. Several hours later he learned of the death of his friend. It was a terrible shock. With the death of Apollinaire, Picasso had lost the most understanding of the friends of his youth. An era was coming to an end, and Picasso was overwhelmed with grief. When he received the telephone call with the news of his friend's death, Picasso had been standing in front of a mirror making a self-portrait; he immediately abandoned the drawing, and it was many years before he did another portrait of himself.

A New Style?

Picasso had changed not only his milieu and his manner of living; he also changed dealers. In postwar France there was a ferocious anti-German sentiment. Cubist painting was labeled as "kraut." The assets of Germans living in France had been confiscated during the war. Kahnweiler, Picasso's dealer and friend for ten years, was German. In a matter of days his prestigious Cubist collection was sold, the pieces disseminated, and the gallery closed. That year, 1918, Picasso chose Paul Rosenberg as his new dealer. Rosenberg

Portrait of Guillaume Apollinaire, 1916. Picasso used simple lines to draw his poet friend in military uniform. Apollinaire was back from the war; his military cap masks the bandage covering the wound he received at the front. On the occasion of a painting exhibition, Apollinaire wrote in an article: "People say of Picasso that his works show a precocious disillusionment. I don't agree. Everything charms him, and his incontestable talent seems to me to be at the service of a sense of fantasy that mixes the delicious and the horrible, the abject and the delicate."

represented a kind of art that was more realistic, more immediately captivating, and thus more accessible to a larger public. He organized exhibitions in his gallery on the Faubourg Saint-Honoré, near where Picasso lived. The prices of Picasso's canvases were already quite high for an artist barely forty years old. Picasso was on the way to being very rich.

Little by little, his pictures began to show traces of a style never before seen, featuring draped figures, goddesses of antiquity, massive forms with the weight and immobility of statues. These pictures had a heavy, emphatic realism. Picasso was violently chastised by many of his followers for having changed styles, for having betrayed Cubism. But to those who accused him of opportunism, Picasso responded one day in an interview, "Each time that I have had something to say, I said it in the manner in which I felt it ought to be said."

Picasso did not change styles in the way one changes clothes or opinions, but in response to deep necessity. It was the surging and continuous wave of ideas bubbling up in him that called forth this multitude of forms that demanded expression. His style was precisely that: He chose the most accurate and appropriate manner to express a strong idea. In reality, throughout his career, Picasso painted in only two ways: as a realist and as a Cubist.

Paulo Picasso, Picasso's First Son

Paulo was born in February 1921. That year Picasso rented a spacious villa in Fontainebleau, just outside Paris. He adored his son, and he loved Olga, as one can see in the drawings he made of her breast-feeding their child or playing the piano. But he was not completely happy in his new role as head of a bourgeois family. It is said that he would confide in friends who came to see him that he wanted to buy a Paris streetlight and a street urinal to "liberate the green lawn from its respectability."

Yet he was truly crazy about Paulo. He loved watching him grow and adored playing with him. One day he entertained himself by decorating one of Paulo's little miniature cars. He finished off his work with a charming

Starting in 1914, Picasso returned to a more traditional representation of reality. In the art world there w[as] a unanimous cry: "Picasso has left Cubism!" This cry became an uproar when Picasso exhibited—in 1919, 1920, and 1921 —drawings that the critics described as "Ingresque" (inspired by the neoclassical 19th-century painter Jean-Auguste-Dominique Ingres) and canvases of an unrestricted classicis[m] But Picasso was vehement on the matter of style. "Away with sty[le] Does God have a style? He made the guitar, the harlequin, the basset hound, the owl, the dov[e] Just like I did. Now, the elephant and the whale: fine. But the elephant and the squirrel? A mishmash! He made what didn't exist. Me too. He even made painting. Me too."

colored checkerboard pattern on the floor. But Paulo burst into tears: A "real" car would never have a checkerboard for a road. Picasso was dumbfounded.

In the summer, Pablo, Olga, and Paulo would often leave Paris for three or four months. After one of these long absences, Picasso returned to Paris to find his winter suits in quite a state—they hung like dead leaves, transparent, with only the traces of wool threads. Moths had devoured everything that was edible! Only the framework of the thick seams and linings was left, and one could see, as if it were an X ray, the contents of the pockets: keys, pipes, matchboxes, and other objects that had resisted the moths' attack. The sight enchanted Picasso. The problem of transparency in painting had preoccupied him from the beginning of Cubism, when the desire to see behind the surface of things had led him to break apart forms. This time it was as if nature were showing him the road to take.

The following summer, in Brittany, there appeared on Picasso's canvases a new sort of Cubist still life: Transparent light floods the picture, with striations that give the space a fluidity, as if what is viewed were seen through water—a filtered transparency, like light passing through shutters.

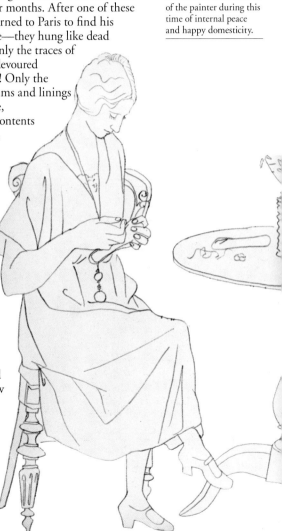

O*lga Sewing,* 1921. Tranquility, serenity, classicism. This drawing admirably outlines the state of mind of the painter during this time of internal peace and happy domesticity.

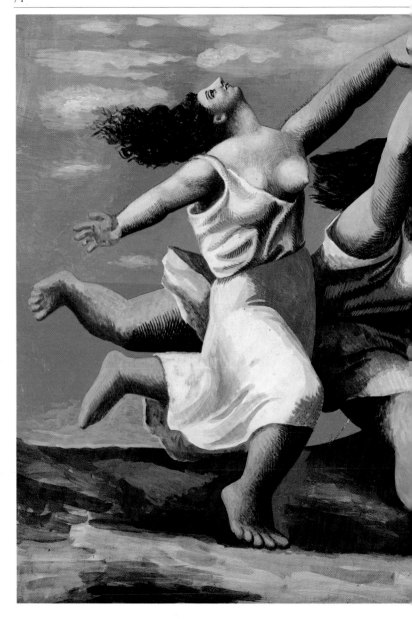

W*omen Running on the Beach,* 1922. These two female bathers are giants. Their feet seem to shake the ground. And yet they run—intoxicated with freedom, seeming to exist outside time—with the grace of ballerinas. During the 1920s Picasso went regularly to the seashore. Fascinated by the bodies of bathers, he put them through strange metamorphoses. When he had visited Rome Picasso had been extremely impressed by Roman statuary. The majesty of the statues of athletes, warriors, and goddesses inspired in him a sense of grandeur that corresponded with his own vision of the human body. Here, the theatrical element, always present during that period of Picasso's life, fused with the monumental forms of Roman antiquity. This gouache served as a model for the curtain of a ballet by Cocteau and composer Darius Milhaud, *Le Train Bleu (Blue Train).*

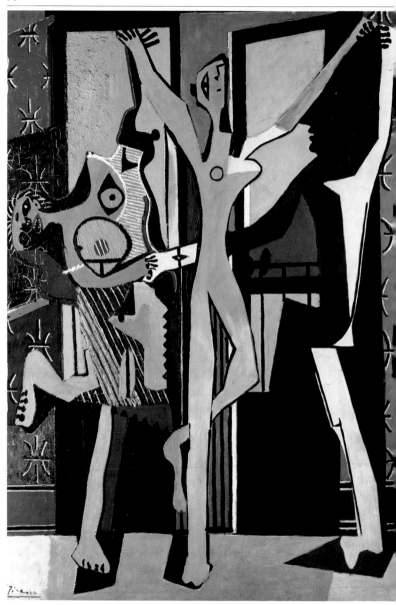

For several years Picasso had been drawing and painting classical themes in a classical way, and nobody was shocked. Many of these were family portraits—mainly of Olga and Paulo. Suddenly, in June 1925, a picture appeared that flabbergasted critics and upset everything: *The Dance.*

CHAPTER V
GENIUS IN ISOLATION

The Dance (1925, opposite). Dislocated bodies, vivid colors, the syncopated movements of three figures—a woman with her head reversed, a leg raised, and a breast in the air; another whose arms are raised as if she were being crucified; the dark profile of a man whose forked hand holds that of the first woman. With this picture Picasso is said to have been "bent on expressing drunken abandonment to unleashed instincts." Right: Picasso photographed by Man Ray in 1937.

When Picasso expressed a feeling strongly, whether a violent or a gentle one, it was always in painting. *The Dance* had begun a veritable groundswell. There were those who adored it, and those who virulently took the opposite view. But all who had followed the development of Picasso's work knew that he was in the process of creating one of those unpredictable and provocative breaks in style to which he had already accustomed them.

The painting showed an unprecedented violence; it was an aggressive, tortured canvas, with bodies deformed as if by fire or madness. Its colors were violent, its dancers seemed torn asunder, their facial features pointing in all possible directions. In places the picture verged on the nightmarish, on the monstrous—terrifying faces, hair like bristles, fingers like carpenter's nails. This was a work far removed from well-behaved little portraits showing Paulo dressed as a harlequin.

It is true that for some time, something had been simmering in Picasso, a dark furor rumbled inside him. His marriage seemed to be becoming a relationship of misunderstanding and distance. For Olga, Picasso's painting possessed only a worldly value; her authoritarian spirit, disciplined nature, and taste for propriety drove Pablo to distraction. He felt like he was in prison. He wanted to break free of his bonds. He wanted to explode. And he did.

But Olga was not the only cause of this violent rupture. There was something else: an extremely powerful literary and cultural movement that had become a rising force in 1924. This movement was called Surrealism, the juxtaposition of unnatural or incongruous elements to create fantastical imagery.

"Beauty Shall Be Convulsive," Surrealism Proclaimed

The war had had a varying impact on art, as on everything else. For some, it provoked a reaction against the violence of trends such as Cubism. And it helped give birth to the movement called Dada, which celebrated the negation of traditional artistic values. But the movement with which Picasso felt an immediate kinship was Surrealism.

Its literary inventors were Paul Eluard, André Breton,

In 1924 André Breton (above) laid down the bases of Surrealist poetry in the first Surrealist manifesto: the exploration of the unconscious and the search for a new language released from the constraints of "reality." In homage to Apollinaire, who invented the word, Surrealism was born.

Philippe Soupault, and Louis Aragon. If Apollinaire had still been alive, he would have been among them. These poets, journalists, and novelists wanted their group to be the interpreter of all modern thought, and, in 1924, André Breton published the first Surrealist manifesto, which announced that "a new declaration of the rights of man must be made." The group also launched a new journal called *La Révolution Surréaliste*. The first issue featured one of Picasso's "constructions," dated 1914. Composed primarily of poets and painters, the Surrealist group had a definite, expanding presence within the modern movement. The Surrealists wanted to plumb the depths of artistic creation and to scour the landscapes buried deepest in the world of dreams and the unconscious. This had been attempted several decades earlier by poets such as Charles-Pierre Baudelaire (1821–67) and Stéphane Mallarmé (1842–98). And already broached by a painter named Pablo Picasso.

André Breton wrote: "Beauty shall be convulsive or shall not be." And what painting—executed at that very time—exemplifies these words better than Picasso's *The Dance*? Breton defined the word "surrealism" as follows: "By it, we have agreed to designate a certain psychic automatism that corresponds more or less to the dream state." How could Picasso not be attracted by the nascent Surrealism? He who had never ceased to paint, to look behind things, or in front of things? He who never painted things in their "real reality" but rather in their "sur-real reality"—exactly what André Breton had called the "internal model"?

In the spring of 1926, Picasso began work on a Guitar series made of aggressive assemblages of fabric, string, old nails, and knitting needles. In these collages the break

Guitar, 1926. This assemblage of a coarse dishcloth with a hole in it, string, nails, and a strip of newspaper is an aggressive representation of a guitar, a painful-looking manifestation of Picasso's feelings of isolation and violence.

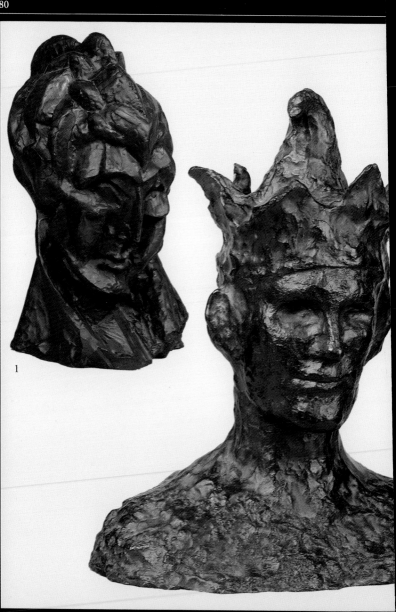

1

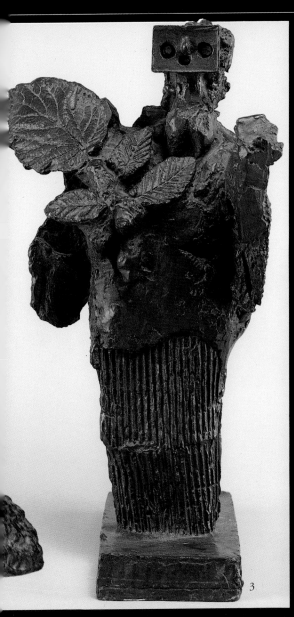

A Jester and Women in Bronze

One of the greatest sculptors of the 20th century, Picasso invented numerous sculptural forms and experimented with many new materials and techniques. He modeled with plaster, wood, cut-and-folded cardboard, and sheet-iron; he also assembled found objects, opening up new directions for modern sculpture.

1. In 1909 Picasso began to break up the volumes of traditional sculpture to deconstruct it into multiple angular facets, as can be seen here in *Head of a Woman (Fernande)*. 2. One of his first sculptural works was *The Jester*, 1905, a classical sculpture in the round based on one of his favorite themes. This began as a bust of his friend Max Jacob. 3. During the 1930s Picasso started a new method of modeling by imprinting plaster with materials or objects chosen for their form or texture. To make the head of this work, *The Woman with Leaves*, 1934, he poured plaster into a rectangular box; to create the folds of clothing, he poured it onto corrugated cardboard. The imprint of leaves with their veins gives this sculpture the pulse of life.

3

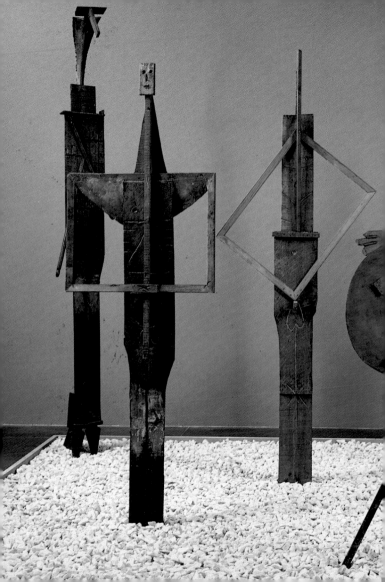

Picasso collected much of what passed through his hands (string, boxes, nails, worn-out objects), with the idea that "it can always be used for something." Handyman and ragpicker of genius, he knew how to breathe new life into the most useless, everyday objects he transformed them through his ingenious sense of invention.

The Bathers, 1956. From left to right: *The Woman Diver, The Man with Clasped Hands The Fountain Man, The Child, The Woman with Outstretched Arms*, and *The Young Man*. This is the only sculptural group in Picasso's oeuv The long, geometric figures are made out of crudely assembled pieces of wood. One can make out the feet of bedsteads, a broom handle, and picture frames. Indications of anatomy are incised in the wood. Using these flat, simplified forms, Picasso managed to create expressive figure that are full of life.

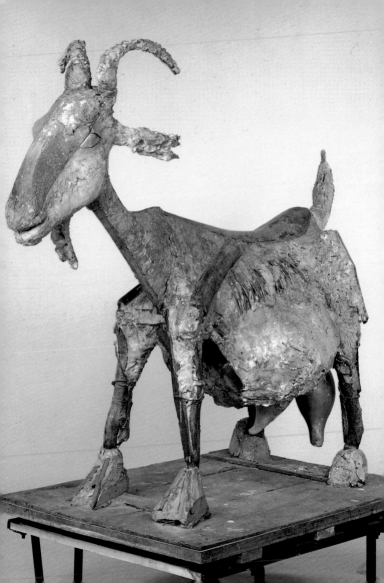

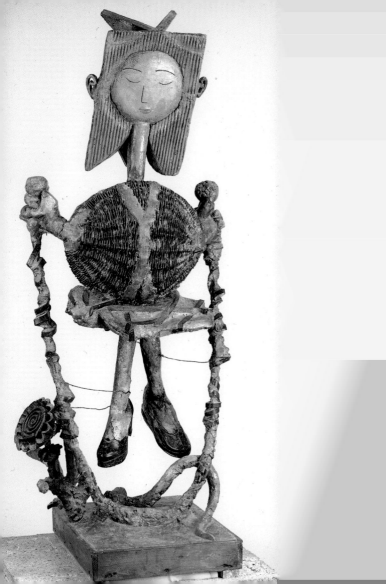

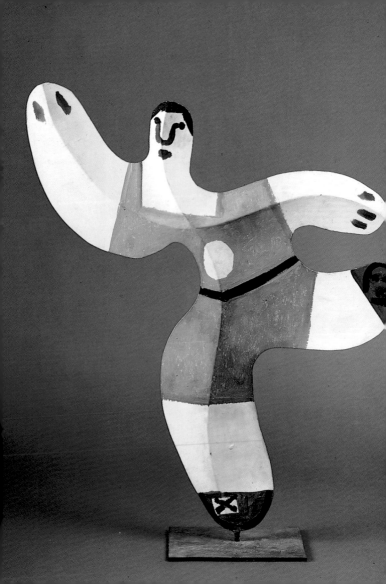

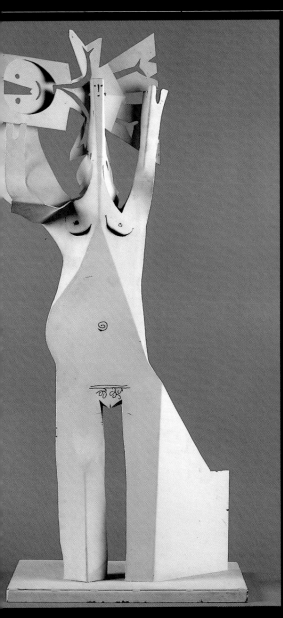

Sheet-Metal Cutouts

The last contribution Picasso made to the sculpture of his time was the 1960s series of cutout and painted sheet-metal pieces. He would take a piece of paper, cut it according to a predetermined design, and then fold parts of it so that it shaped itself into a figure, the resulting angles suggesting a relief. Finally, copies of the paper or cardboard maquettes were fabricated in sheet metal.

Footballer (1961, opposite). With his full, round forms and cheerful colors, the soccer player darts buoyantly forward to kick the ball. Paint gives a schematic indication of his clothing, face, feet, and hands. Throughout his life Picasso maintained a close dialogue between painting and sculpture. "It is enough to cut a painting to arrive at sculpture," he said.

Woman and Child (1961, left) is more complex. The body of the child, held in the arms of the mother, is folded and then cut at the folds, creating shaped holes like those in paper snowflakes. Despite being made of sheet metal, these sculptures preserve the fragility and lightness of the original material.

with harmony and propriety was complete. The reality of objects, that is, their inherent function, was diverted. This was Picasso's own unique approach to Surrealism. The advent of Surrealism in 1925 and 1926 served to reinforce the explosive tendency he had already carried within himself for some time.

Marie-Thérèse: A New Face, a New Muse

Picasso met seventeen-year-old Marie-Thérèse Walter one cold day in Paris in January 1927, on a street near the Galeries Lafayette department store. He told her his name, but she had never heard of him. Still married to Olga, Picasso fell desperately in love.

Marie-Thérèse was stunning, with a calm, deep, sculptural, reflective beauty. She was also fiercely independent and free spirited. Picasso told her right away, "We are going to do great things together." From that moment on, he never stopped painting her face. He found Marie-Thérèse living quarters near where he lived, on the Rue La Boétie. But this passionate affair would remain hidden for many years. What was disclosed of Marie-Thérèse during these many years was disclosed in Picasso's painting and sculpture, the beautiful, deep lines, the full forms that her face, her body, and his love for her inspired. This new muse prompted Picasso to revive the grand classical style, as can be seen in the etchings commissioned by Vollard in 1927—around a hundred plates of simplified line drawings representing antique figures: a sculptor carving a marble statue, mythological beings, gods, and goddesses.

Above: Marie-Thérèse Walter photograph in Dinard, Brittany, in the summer of 1929.

Left: *Bust of a Woman*, 1931. This bronze sculpture, with its large nose extending from the forehead, was modeled after Marie-Thérèse. It was executed in Boisgeloup, in the stable that Picasso had converted into sculpture studios. Picasso never tired of Marie-Thérèse. He enshrined her round, full forms and voluptuous grace in sculptures, paintings, and engravings.

Picasso Found Peace in His Boisgeloup Château

In 1930 Picasso bought a delightful 17th-century manor house located just outside Paris on the outskirts of the pretty village of Boisgeloup. Next to the front gate was an elegant little Gothic chapel. The chapel opened onto a great courtyard which was presided over by the vast main structure of gray stone, topped by a slate roof. But what most captured Picasso's attention was the long row of stables. Picasso immediately turned these into sculpture and graphics studios. He had recently met engraver Louis Fort and sculptor Julio González, both of whom had urged him to return to these disciplines.

That year Picasso was happy: In Boisgeloup he had found a retreat where he would work with feverish concentration, an essential condition for his finding lasting contentment. Having recaptured some of that

For several years, 1927–37, Picasso was under contract to Ambroise Vollard to provide him with illustrations. During this ten-year period, Picasso produced around a hundred engravings and etchings, now known collectively as the Vollard Suite. *Sculptor at Rest* (1933, below) is part of a subseries of the suite entitled The Sculptor's Studio.

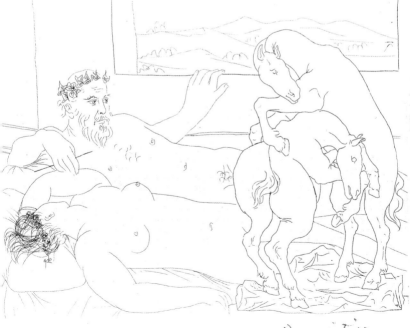

contentment, the existence of his new muse, even far away and secret, gave birth to a large number of sculptures—all variations on busts of Marie-Thérèse. With González, he discovered new possibilities in metal sculpture. His experiments in collage had already shown him that unexpected things could result from assemblages of actual objects: scraps of metal, springs, lids, strainers, bolts, and screws—all chosen with care from public dumps. Or sometimes Picasso would take the penknife that he always had in his pocket and cut long pieces of wood into human figures that he would then have cast in bronze.

During This Difficult Period, Sabartés Was a Faithful Friend

The time at Boisgeloup was blissful. But it was really only a period of calm before the storm. The arguments with Olga became unbearable. In June 1935, for the first time in years, Picasso did not leave Paris for the summer with his family. He let Olga and Paulo depart on their own; he stayed home alone. Olga was never to return.

Marie-Thérèse was expecting a child.

Picasso wrote to his friend Sabartés during this period, "You can imagine what has happened and what awaits me still." Picasso's loneliness had become more than a manifestation of the inevitable isolation of genius. To escape the elegant and empty world he had been dragged through for the last ten years, he hid himself away, his work his only consolation. But friendship and affection had always been necessities for him; so he called Sabartés to the rescue, asking him to come to Paris to live with him through that difficult period. Sabartés took the next train. From that day until Picasso's

death thirty-eight years later, Sabartés would remain his closest friend and confidant.

Marie-Thérèse gave birth to a girl, whom they called Maïa. (Her real name was María de la Concepción, the same as the little girl who died so many years ago in La Coruña.)

The "Worst Time of My Life"

Daily life had become complicated. There were Olga and Paulo, and there were Marie-Thérèse and little Maïa. Lawyers, who cost him dearly, were not able to work out a settlement with Olga; she simply did not want a divorce. Picasso was floundering—he lost his peace of mind, his concentration. He was no longer able to work. In a letter he wrote, "It is the worst time of my life." In the autumn he fled to Boisgeloup, his hideout, his sanctuary. There, in secret, he began to write.

He wrote for himself alone. For months he showed no one what he put in his notebooks, almost as if he feared it would disappear as soon as someone looked. Then, little by little, his need to communicate led him to read fragments from the notebooks to close friends. In some of his first attempts at Boisgeloup, always obsessed with the idea of substituting one art form for another—to "write pictures" and "paint poems"—he used blobs of color to

B *ather Opening a Beach Hut,* 1928. The canvases of 1927–9 brought forth a strange, distorted, and enigmatic portrayal of the female figure. The women fragment and take on a grotesque or threatening appearance. This is the most famous portion of Picasso's work, and that which caused the greatest scandal, for he took on what had hitherto been the most sacred subject matter of painting: feminine beauty.

L eft: Picasso seen in his Rue La Boétie studio in 1929. On the floor is the small *Bather Opening a Beach Hut* canvas.

stand for objects or words in his poems. Then he began to write, punctuating his work with phrases that were highly visual, colorful, in a style uniquely his own—in exactly the same way that he had worked earlier with his collages. Indeed, he treated words like paper cutouts, the color of the canvas as punctuation to separate sentences. The words made colors sing. Picasso loved that, he found he loved to write. Picasso's friend André Breton was among the first to embrace his poems with enthusiasm. Several were published in a special edition of the magazine *Cahiers d'Art* (Art journals).

In 1936 Civil War Broke Out in Spain: Picasso, Shattered, Took the Side of the Republicans

In March 1936 Picasso left for Juan-les-Pins, on the French Riviera, with Marie-Thérèse and Maïa. Once again he was plagued by dark moods. He could not bring himself to paint, and that made him extremely crotchety. For six weeks Sabartés received dark, confused, and contradictory letters: "I am writing to you immediately to announce that beginning this evening I am abandoning painting, sculpture, graphics, and poetry to devote myself entirely to singing." Then, a few days later: "I continue to work, despite singing and everything." His moods were changeable, full of disarray and tumult. Something had broken the external equilibrium he needed to work.

In July 1936 civil war broke out in Spain—the new Spanish republic was toppled by right-wing rebels led by General Francisco Franco. Picasso had always had a vital, fundamental love of freedom—his own and that of others. With the war in Spain, it was the freedom of his own people, of his own country, that was threatened. His sympathy naturally lay immediately on the side of the Republicans.

Brigades were formed in Europe and America to defend the cause of liberty. Many of Picasso's friends left to fight in Spain. The war was a premonitory cloud in a period that would soon see the Nazi horror sweep across Europe. Around the world clear-sighted men and women knew that it was necessary to resist. To stand alongside the Spanish Republicans in 1936 assumed a symbolic meaning: The struggle against fascism had started.

Maïa with a Doll, 1938 (opposite). One eye seen straight on the other to the side, nose in profile, a large mouth: Picasso was trying, as he had in the days of Cubism, to represent two views at the same time. Despite these deformations, it is easy to recognize Marie-Thérèse and Picasso's daughter, painted here at age three. In this chaotic picture, only the doll is represented in a fairly traditional manner.

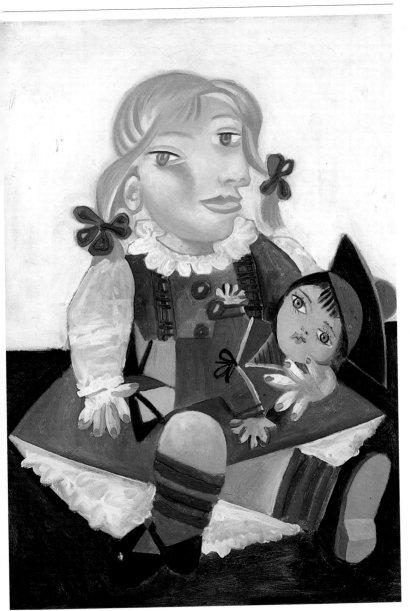

After his return from Juan-les-Pins, however, Picasso was in a more sociable mood. Almost every evening he went to a café on Saint-Germain-des-Près, in Paris's Latin Quarter, where he spent long hours chatting with friends. One evening Paul Eluard introduced him to one of his friends, a young girl with beautiful dark eyes filled with fire. Possessed of a rapid and determined manner, quicksilver intelligence, and a willful, well-defined character, Dora Maar was a painter and photographer. She spoke Spanish fluently. Right away, Picasso had long and colorful conversations with her in his own dear Spanish. And Dora Maar understood his other language, painting, just as well as the first.

The Savage Bombardment of Guernica

The summer of 1936 found Picasso in Mougins, a little village inland from Cannes. He was surrounded by friends: Paul Eluard and his wife, Nusch, Dora Maar, art publisher Christian Zervos and his wife, Picasso's dealer Rosenberg, and painter and photographer Man Ray. Around the dinner table, conversation would invariably return to the war in Spain. News was bad: Fascism was spreading; the Republicans were being massacred.

The French government had chosen 1937 as the year to hold the Universal Exposition in Paris. For the representatives of the Popular Front—the coalition of leftist parties in Spain—it was vital that the Spanish government be suitably represented. They asked Picasso to create something that would clearly show the world where his sympathies lay. Picasso promised to create something so large it would occupy an entire side of the pavilion.

He needed an immense studio to work in, and Dora Maar quickly found the perfect space—a beautiful 17th-century house on the Rue des Grands-Augustins, in the very heart of Paris.

On 28 April 1937 an atrocious bit of news reached Paris: German bombers in Franco's employ had savagely attacked the small Basque town of Guernica. They had bombed at an hour when the streets were full of people.

Just over a month later, on 4 June 1937, a painting exited Picasso's studio: *Guernica* was flung before the eyes

of the public. Picasso had responded to the most horrible of massacres by making one of the most earthshaking paintings that perhaps had ever been painted. To the bloody bombers blind with horror and beastliness, Picasso had responded with eyes opened by a bomb of vitriol. *Guernica* would be the greatest tragic painting of the 20th century.

The Dream and Lie of Franco. In January 1937 Picasso engraved two plates, accompanied by a poem: *Sueño y Mentira de Franco,* a ruthless protest against the tyranny of Franco. Here the dictator is depicted in loathsome form, as a kind of evil knight whose adventures are recounted in rectangular drawings in a format reminiscent of comic strips. He accompanied this work with a protest: "...cries of children, cries of women, cries of birds, cries of flowers, cries of girders and stone, cries of brick, cries of furniture, of beds, of chairs, of curtains, of pots...." The violence of his reaction to the tragedy that was ripping apart his country makes one understand to what degree Picasso had remained Spanish.

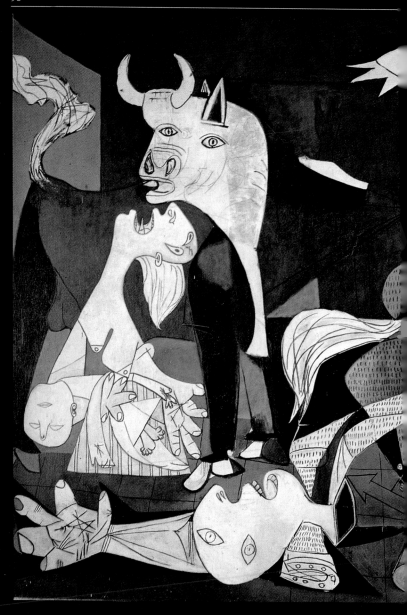

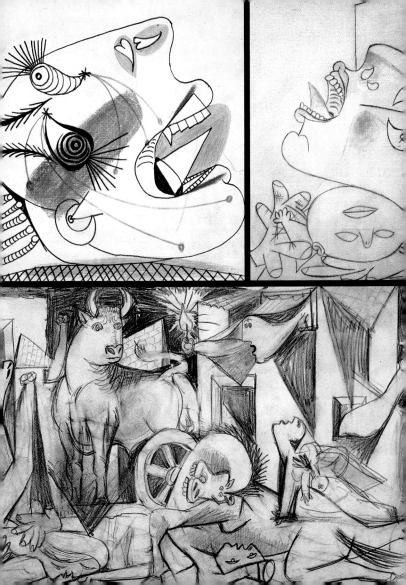

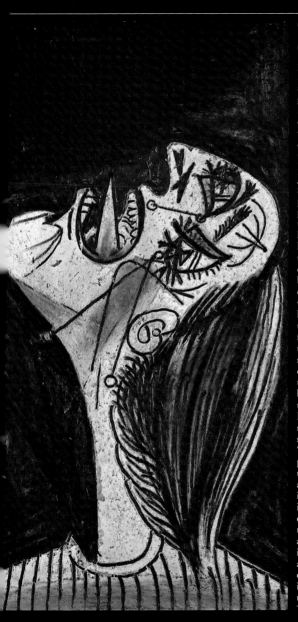

Guernica

Guernica, 1937 (gatefold, preceding pages). It is difficult to imagine that the modest sketches on these pages gave birth to Picasso's most powerful pictorial creation, *Guernica,* the very symbol of revolt, the cry of indignation before the horrors of fascism. Between 1 May and mid-June 1937, Picasso made forty-five studies. The principal elements were present in the very first: the bull, the woman holding a lamp, and the horse. Picasso expresses a universal drama in this canvas—that of war, of blind violence, of children dead, of mothers weeping. To say all this he turned to his personal universe, and to the figures of the bullfight, the horse and the bull, symbol of "brutality and darkness." Picasso chose to limit his palette to black, white, and gray, the colors of mourning. Forms are flat and simplified, as on a poster, so as to be more striking. "How could it be possible to be uninterested in others, and, by virtue of what ivory-towered indifference, to be detached from the life they bring you in such abundance? No, painting is not done to decorate apartments. It is an offensive and defensive instrument of war against the enemy."

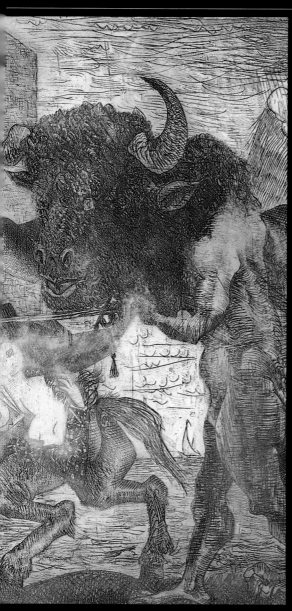

Minotauromachy

Minotauromachy is a word Picasso invented to combine the themes of the Minotaur and the bullfight. In this celebrated engraving entitled *Minotauromachy* (1935), the scene takes place at the seaside. The Minotaur can be seen advancing menacingly toward a young girl holding a candle. A bearded man flees up a ladder. In the center a frightened horse carries a woman with her sword. Two young girls with two doves watch this strange scene through a window. This engraving is intended to illustrate the combat between the forces of evil—personified by the Minotaur—and those of good, of innocence—represented by the young girl. In Greek mythology, the Minotaur had the body of a man and the head of a bull, and was half mortal, half god. The monster was confined in a labyrinth on the island of Crete and given tributes of young boys and girls until he was finally slain by Theseus. To this mythology, Picasso added that of his own country: the bullfight, the tragic and mortal combat between human and animal—an animal that symbolized strength while at the same time was a victim. Picasso often identified himself with the Minotaur.

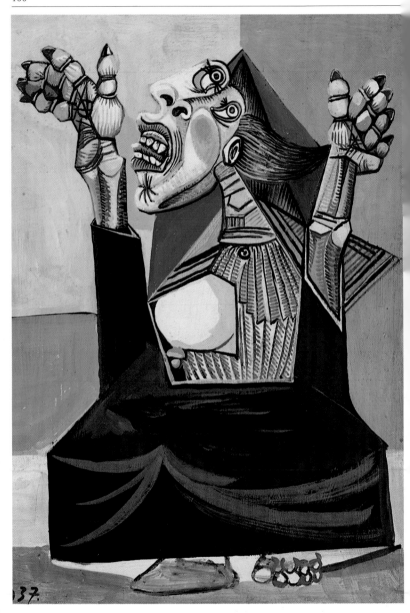

137.

The year 1939 was marked by a double face, a double presence: Marie-Thérèse and Dora. Picasso painted innumerable portraits where one face substituted for the other. Once he even painted portraits of both women in the same pose on the same day. Dora's strong features fascinated Picasso, and he painted them thousands and thousands of times.

CHAPTER VI
FOLLIES AND TORMENTS

The Suppliant (1937, opposite). This squat woman, monstrous and afraid, raises her hands toward heaven, expressing the suffering of the mothers and widows torn apart by the Spanish Civil War. At right, Dora Maar in 1941.

In Europe, political events were coming to a head. Hitler in Germany, Mussolini in Italy, Franco in Spain: The shadow of war loomed. The word was on everyone's lips. Picasso went every evening to sit in one of the cafés in Antibes, on the Riviera, where he was spending the summer with Dora. During these discussions, it seemed that nobody had any doubts that war would soon erupt.

Europe Engulfed in War, Picasso Had To Stop His Work on *Night Fishing at Antibes*

In August 1939 Hitler invaded Poland. The French were mobilized. As in 1914, Picasso saw his friends leave and the city fill with troops. Irritated that he had to interrupt his work on *Night Fishing at Antibes*, he said jokingly that "they" must have declared war simply to annoy him. He left Antibes and went back to Paris.

Arriving after a miserable night in a packed train, Picasso found the city in a state of panic. Immediate bombardment was feared. He left quickly for Royan, a small seaside town seventy-five miles north of Bordeaux, taking Dora Maar, Sabartés, and his dog, Kasbec, with him. Marie-Thérèse and Maïa were already there.

In Royan he rented an apartment on the upper floor of a villa with an impressive view of the sea. "This would be good for someone who thinks he is a painter," Picasso said ironically. Still, he painted, and when he painted, the war was far away. He had no traditional artists' materials: Wooden planks served as canvases; for a palette, he used seats of chairs; and, as there was no easel, he painted squatting on the ground. In the middle of war, with everything falling apart around him, he painted. The activity helped prevent his giving in to the general panic that had seized many of the French.

Nonetheless, one summer day in 1940, Picasso saw the steel helmets of the Germans entering Royan and the ominous deployment of tanks and cannons. General Philippe Pétain, the French commander, had signed a treaty with Hitler. France was under German occupation. There was no more reason for Picasso to remain in voluntary exile in Royan. He returned to Paris and moved into his studio in the Rue des Grands-Augustins.

Restrictions, difficulties in replenishing supplies,

Night Fishing at Antibes (1939, opposite above). In this his largest canvas since *Guernica,* Picasso paint a way of life at the port: night fishing using acetylene lamps; the fis are attracted by the ligh from a lamp placed on the bottom of the boat. With a four-pronged spear, one of the fishermen harpoons a square fish; the other leans dangerously over the water to catch anoth with his hand. Two spectators—Dora Maar and Jacqueline Lamba, André Breton's wife—a walking along the quay licking an ice cream co and pushing a bicycle. The Mediterranean nig is depicted in dark blue and mauve. Faces and bodies are violently distorted. The painting surface is divided into geometric elements. In Picasso's vocabulary, fis and crustaceans are sig of violence and cruelty— at the heart of daily life the threat of war.

Cat Catching a Bird (1939, opposite below). Picasso never depicted the war itself, but during those years his painting was imbued with the violence and anguish that accompan it, and the most mundane subjects— a cat and bird—are transformed into images of almost unbearable cruelty.

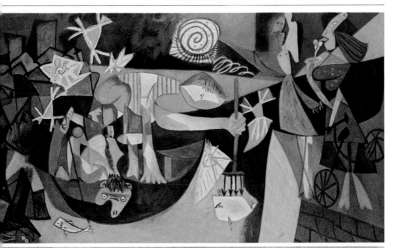

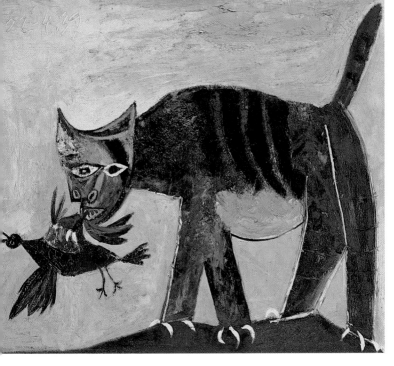

deprivations of all sorts—life in Paris was hard. Air-raid sirens sounded daily, and people rarely went out. Picasso almost never left his neighborhood, except to visit Marie-Thérèse and Maïa, who were living near the Seine on Ile St. Louis, or to dine with friends at the little restaurant called Le Catalan in his honor.

Below: Picasso's illustration for the frontispiece of his play *Desire Caught by the Tail*, 1941.

In the Stifling Atmosphere of the German Occupation, Picasso Worked

Understandably, the atmosphere was tense, but despite everything, people had to work out a means of living. They had to react. For Picasso that meant looking for ways in which it was still possible to create, even when destruction was everywhere. One January evening in 1941, during a long, bitterly cold evening, Picasso picked up an old notebook. He began by writing a title on its cover: *Le Désir Attrapé par la Queue (Desire Caught by the Tail)*. Then, on the first page, he drew a pen-and-ink portrait of the author the way a fly perched on the ceiling of the studio might have seen him, seated at the table, his glasses jutting out from his forehead, pen in hand. What followed was a play in six acts, a farcical tragicomedy, with characters called Big Foot, Fat Anxiety, and the Tart, who talk about love and food.

Four days later, on 17 January 1941, Picasso drew a line after the last act and wrote "End of the play." Those of his acquaintances who read the work convulsed in laughter. Three years later a more formal reading was organized, friends taking various parts: writers Jean-Paul Sartre and Simone de Beauvoir, humorist Raymond Queneau, writer Michel

PORTRAIT D L'AUTEUR

Leiris and his wife, Louise, and others. Everyone spoke of it as an unforgettable event.

At the beginning of 1944 Paul Eluard wrote, "More and more, Picasso paints like God or the Devil." And he added, "He has been one of the rare painters who have behaved well, and he continues to do so." And it was true; during the war some artists had let themselves be seduced by offers from Germans.

Picasso Continued To Create "Revolutionary" Paintings Under the Noses of the Nazis

Picasso's reputation as a revolutionary would have sufficed on its own to condemn him. He was a master of everything that Hitler most feared and suspected in modern painting, creator of what the Nazis called "degenerate art," or art-Bolshevism (*Kunstbolschewismus*). With *Guernica*, Picasso had clearly demonstrated his hatred of fascism. One day, the Gestapo came to search his house. A Nazi officer, seeing a photograph of *Guernica* on the table, demanded, "Is that you who did that?" "No, it is you!" retorted Picasso.

In the spring of 1944, he appeared in public for the burial of his friend Max Jacob: Jacob, a Jew, had been arrested by Nazi police and deported to a concentration camp, where he died.

The sinister background of the war and its deprivations made itself felt in many of Picasso's pictures during this period. As always, what he painted was what he saw. During this time of war, innumerable animal skulls illuminated by the dim light of candles appeared, as well as leeks and sausages; and naked, gleaming, sharp-pointed knives and twisted—hungry—forks. Everything in his still lifes recalled the war.

M *an with a Sheep* (1943). In 1950 Picasso offered a copy of this bronze statue to the village of Vallauris. It stands today in the town square.

On the morning of 24 August 1944, all Paris was awoken by gunfire from snipers hidden on the roofs shooting at retreating Germans. The city had been liberated. A feverish excitement took hold. Picasso found himself in the very heart of the battle of the liberation. Friends would arrive furtively at the Rue des Grands-Augustins to tell him hour by hour how events were unfolding. They left again under sounds of explosions and cannon fire. For his part, Picasso threw himself into his work, while the windows of his studio threatened to shatter from explosions outside. As he painted he sang at the top of his lungs to muffle the din from the streets.

Hardly had the crackling of gunfire stopped when friends serving with the Allied forces began to arrive. During the war years, news about Picasso had been scarce. It was known only that he had stayed in Paris. In liberated Paris, there was a race to see who could get there first! The number of visitors soon was almost overwhelming. Every morning the long narrow room on the floor below the studio would be full to bursting with visitors. Picasso was virtually besieged, mostly by Americans and English, who spoke neither Spanish nor French. Still, he left a deep impression on the thousands of people who came to see him during those days.

The Face of Picasso's New Model Belonged to a Painter, Françoise Gilot

Picasso met lithographer Fernand Mourlot in the fall of 1945. He liked Mourlot's work enormously, and this gave him the idea of returning to a medium that he had not touched since 1919. Nearly every day he went to Mourlot's workshop to print. In the first lithographs appeared the face of his new beloved, Françoise Gilot, a model whom he had met through friends two years earlier.

The following spring Picasso brought Françoise to the Mediterranean coast—"his landscape," as he put it—where he was happy. With Françoise, who was young, beautiful, and a painter, he was once again content. After the terrible war years, it was freedom, creative freedom, that had regained the upper hand. He began again to do an enormous amount of work— lithographs with Mourlot, but also many new canvases.

There were portraits of Françoise, but also more mythological fauns and centaurs, and, once again, Minotaurs. The Minotaur had returned along with the Mediterranean, and he felt a very particular tenderness for him, as if the animal were to some extent himself.

In this mythological flock, among the fauns, the centaurs, the goats, and the nude dancers, suddenly appeared a new animal: an owl. Somebody had recently given Picasso an owl. It had been wounded, Picasso had cared for it, and they became fond of each other. Picasso was fascinated by his owl, by its bright, piercing eyes, its aloof and distant gaze, a gaze that knew so much. He had always adored birds. This owl and the doves of his childhood, seemingly so different, were his lifelong companions. Both had a profound meaning for him, one no doubt colored by superstition.

One day, as a joke, he took an enlargement of a photograph of his own eyes and covered it with a piece of paper on which he drew the head of an owl. He then cut out two holes in the paper like a mask—the result was astonishing!

In September 1946 the curator of the museum in Antibes, Romuald Dor de la Souchère, put at Picasso's disposal its great, luminous halls for him to work in—a wonderful gift! All the paintings he made there form part of the holdings of what is now the Musée Picasso in Antibes.

By the end of the same summer, Françoise was expecting a child. In May 1947 Claude was born.

Two Doves In Picasso's Life

In 1949 a gigantic World Peace Congress organized by the Communist

Opposite above: *Françoise as the Sun,* lithograph, 1946.

Below: The eyes of this owl are not the owl's but Picasso's own.

Left: Françoise Gilot, Picasso, and his nephew, Xavier Vilato, photographed on the beach at Golfe Juan on the Mediterranean in the summer of 1948.

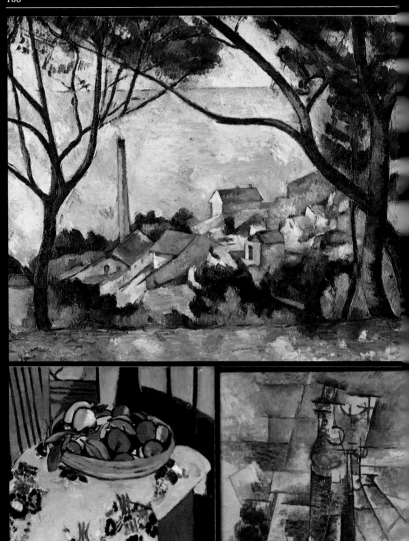

Picasso's Collection

Paul Cézanne, *The Sea at L'Estaque* (1879, opposite above). This painting was the starting point for Cubism. "If only I had known Cézanne!" Picasso said. "He was my sole and unique teacher! You may indeed think that I have looked at his paintings.... I have spent years studying them...."

Henri Matisse, *Still Life with Oranges* (1912, opposite below left). Matisse was an esteemed rival with whom Picasso sustained an association throughout his life. Matisse was color, harmony, and happiness. Picasso was line, dislocation, conflict.

Georges Braque, *Still Life with Bottle* (1911, opposite below right). Braque was Picasso's companion in the heroic conquests of Cubism. Said Braque, "We said together things during those years that nobody will ever say again...things that would be incomprehensible...."

Henri Rousseau, *Portrait of a Woman* (1895, left). The freshness of Rousseau's vision seemed to Picasso and his friends an important direction for painting.

party took place in Paris. Picasso had joined the party five years earlier, just after the liberation, as had many other intellectuals. Belonging to the Communist party had taken on an active meaning in the fight against Nazism during the war. Picasso himself declared at the time, "I never considered painting as an art of simple embellishment, of distraction.... These years of terrible oppression demonstrated to me that I must struggle not only through my art but with my person." (5 October 1944)

In January 1949 the party asked Picasso to design a poster symbolizing the peace movement. Picasso drew a dove—like the white pigeons that he kept in a cage in his Rue des Grands-Augustins studio, like those in Montmartre, like those in Gosol, in La Coruña, and in the trees of his youth in Málaga. A few months later, Picasso's dove appeared on the walls of cities throughout Europe.

That same spring, in April, another dove made its appearance in Pablo and Françoise's life: their daughter, Paloma (a Spanish word meaning "dove").

Vallauris: A Little Provençal Town with Red-Clay Rooftops in the Heart of a Valley Surrounded by Pine Forests

Picasso had discovered La Galloise, a villa near Vallauris, several years earlier on a walk with Eluard. The little town had captivated him from the very first. And it was there that he had moved in 1948, with Françoise and their son.

Vallauris was a village full of ceramicists and potters, practitioners of an art that Picasso had discovered only recently. But soon there appeared on the shelves of Vallauris potters rows of jugs sculpted by Picasso in the forms of doves, bulls, owls, birds of prey, and female heads. He awed his ceramicist friends with his audacity in his treatment of the medium! He defied all rules in the firing of pottery—he managed things that were absolutely unheard of. Taking a vase that the chief potter had just finished throwing, Picasso started to mold it with his fingers, pinching the neck in such a way that the bowl of the vase

Baboon with Young (1951, below). Using found objects—here, two toy cars, a jug, and a ping-pong ball—Picasso discovered what was a new technique for him: the chance object, an "accident" for which he carefully prepared.

ecame resistant to the touch, like a balloon. Then, with a
ouple of adroit twists and pushes, he transformed the
tilitarian object into a dove—light, fragile, breathing life.
You see," he said, "to make a dove, you have to start by
wisting its neck!" It was a sleight of hand of incredible
elicacy: If the pressure had been miscalculated, he would
ave had to roll the clay up and start all over again. But
ith Picasso, errors like that seemed never to happen.

At Vallauris Picasso was happy; he felt wonderful. For
im it was a place of recreation and relaxation in the
niddle of this new family of potters who had become his
riends. Every morning he would appear in the ceramics
tudio in shorts, sandals, and undershirt. Often he went
wimming at noon after working all morning. He was
ctive, and his gestures manifested an extraordinary
itality. Only his white hair betrayed his age: Picasso
vas nearly seventy.

In addition to potting, he was very much involved
vith his new family. He painted and drew his two
small children, their games, and their toys. They
were exactly the kind of children he liked—
cheerful, intrepid, ruthless, overflowing with
energy. He loved to play with them and would
make them little dolls in the twinkling of an
eye out of pieces of wood decorated with
lines drawn with chalk, or animals that
he had cut out of pieces of cardboard,
giving them such bizarre expressions
that they made even adults laugh.
He taught Claude to swim and
to make faces. The beach was
their principal playground,
and the morning swim
often stretched into the
afternoon. The news soon spread in 1950 on the Côte
d'Azur that the Picasso family could be found every
day at a certain beach by lunchtime. As a result,
the restaurant at that beach began to be
filled with a crowd wanting to dine with
him. Thus, in Vallauris, a legend grew.
By the early 1950s, Picasso's name was
becoming a symbol.

This *Man-Faced Owl*
(above) was made
from Vallauris clay in
1953. Picasso had
discovered Vallauris
several years earlier. In
the course of a brief visit
with a potter, he took up
a little clay and passed
the time modeling it.
Returning a bit later, he
was pleased to see that his
efforts had been fired and
carefully preserved. He
became passionately
involved in ceramics.
This art, a combination
of sculpture, painting,
and drawing, was, for
Picasso, "sculpture
without tears."

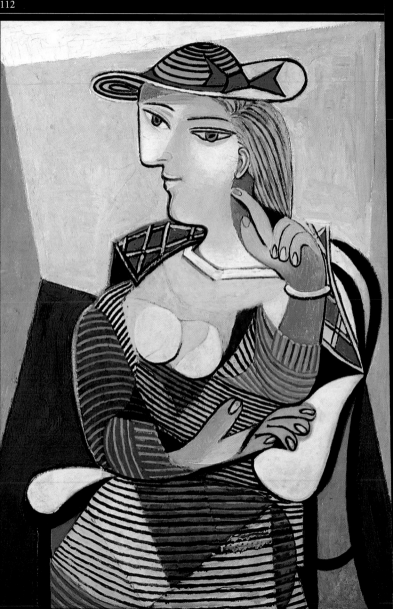

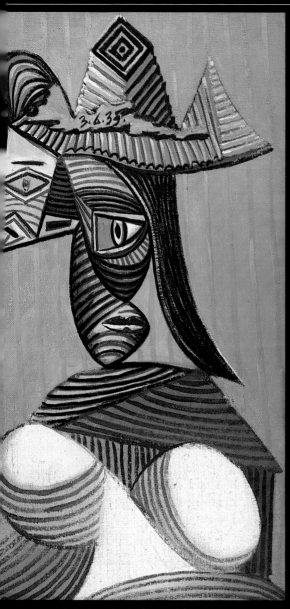

Female Heads

One eye in profile, the other full face, the nose sideways, the chin twisted in an angular or bloated face surmounted by a grotesque hat: This is the way most people see Picasso's painting. His name has become a kind of description. "It's like a Picasso" is often said to mean that something is distorted. Why these deformations? Why did Picasso spend his time shattering the human face, turning it upside down? Each of these portraits expresses a particular vision of women. They are comical, pitiful, dramatic, or grotesque.

Marie-Thérèse (1937, opposite). Always painted in cool, tender colors—blue, green, lilac, yellow—Marie-Thérèse's form is rendered here with curving, harmonious lines. She is easily recognizable in the many, very different paintings that Picasso did of her. He depicted her reading or sleeping, abandoning herself to the painter's gaze.

Head and Shoulders of a Woman with a Striped Hat (1939, left). This woman's face has absorbed the graphic motifs of her environment—in this case, the stripes of her hat.

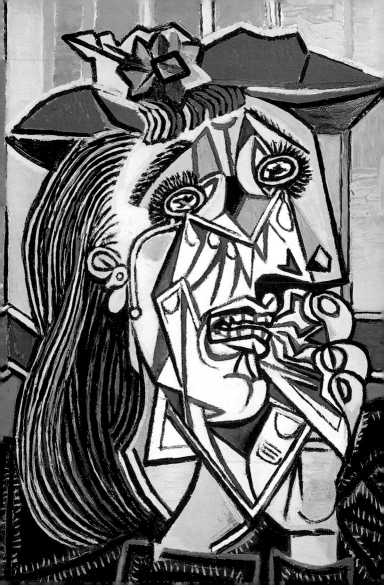

Women in Tears

For Picasso, creating a painting was primary; the fact that it was a portrait of a woman was secondary. He manipulated form, line, and color. He treated the face or body as if it were a construction, a still life whose diverse elements—nose, ears, neck—he could arrange as seemed best to him, reassembling these distortions toward an expressive end.

Weeping Woman (1937, opposite). When a strong emotion is felt, it is often experienced in terms of physical and visual transformations. Various turns of phrase record these deformations: "her eyes jumped out of her head," a "mouth all screwed up," a face "riddled" with tears. These are the sorts of mixed feelings Picasso tried to express through painting.

Portrait of Dora Maar (1937, left). Dora Maar was often represented in black and red, or other lively colors, and angular forms. One can recognize her long red fingernails, her round, determined jaw, her eyes crackling with vivacity and intelligence.

Woman and Flower

Picasso sought to express not only his model's character and her particular gestures, but also the feelings that she aroused in him. For each type of woman there was a corresponding style. Distortions resulted from his desire to show everything on one canvas, to present the female model in all her aspects simultaneously— full face, profile, and three-quarters view. But as there was only one plane, the canvas, the face had to be twisted to allow all these parts to be seen successively.

Portrait of Jacqueline (1954, opposite). Jacqueline Roque—with her Grecian profile, her straight nose and her beautiful, almond-shaped eyes—represented for Picasso the Mediterranean woman par excellence. He often represented her kneeling, draped in Turkish dress. In this portrait he simplified the planes of her face in order to render the rigorous purity of her features.

Flower-Woman (1946, left). Françoise Gilot evoked in Picasso the notion of woman as flower or woman as sun. Her abundant hair radiated like petals; her delicate figure tapered like a stem.

L a Californie was a large turn-of-the-century villa situated in the hills above Cannes on the Riviera. The rooms were cool and bright, illuminated on all sides by great bay windows. At the beginning of summer 1955, Picasso had just passed through a dark, difficult period. His only wish was to flee from bothersome visitors and journalists with their prying questions.

CHAPTER VII
LUMINOUS DAYS

Portrait of Jacqueline in Turkish Dress (1955, opposite). Picasso depicted Jacqueline in this costume because he thought she resembled one of the odalisques in Delacroix's *The Women of Algiers*. Right: Picasso during the 1950s, drawing a bullfight.

Two years earlier Françoise and Pablo had separated, Françoise taking the two children with her to Paris. The intrusiveness of reporters who now tracked Picasso as if he were a movie star added to the tumult of this painful period. But at La Californie he again found the calm that he needed to work. At age seventy-four he set about once again to paint with a passion. He was now living with Jacqueline Roque, a young woman whom he had met in Vallauris a couple of years earlier.

In the Spacious Villa, Picasso Reassembled His Incomparable Collection of Curios

The rooms at La Californie were connected with one another by large doorways. Picasso used all the rooms as studios: In each one, there was a work in progress. Despite Jacqueline's efforts, the disorder was terrible. It was, as always, Picasso's preferred sort of jungle: strange, incongruous objects, open boxes here and there, dried flowers in a vase, piles of clothing, a strangely shaped lamp, food. Wafting over all were the scents of pine and eucalyptus let in by the huge French windows.

Nightfall was magnificent over the hills, and Picasso worked, played with his dogs or his pet goat, and entertained friends. Kahnweiler, his former dealer, Sabartés, and other friends, including Jean Cocteau and poet Jacques Prévert—these were his close companions, always welcome, always invited to dine at the villa.

In February 1955 Picasso had finished a large series of fifteen canvases and two lithographs, *The Women of Algiers,* begun just two months earlier. These were variations on the painting of the same name by Eugène Delacroix. When asked about the quantity of studies, Picasso replied, "The fact that I paint such a large number of studies is simply part of my manner of working. I do a hundred studies in a few days, whereas another painter might spend a hundred days on a single painting. By carrying on, I will open windows. I will go behind the canvas, and perhaps something will be brought out."

That summer filmmaker Henri-Georges Clouzot made a film about Picasso. Using a technique of his own invention, he recorded Picasso's process of creation.

In *The Women of Algiers after Delacroix* (1955, opposite below), after Delacroix's *The Women of Algiers* (opposite above), Picasso kept the composition of the picture and its figures, but interpreted them in his own fashion. The imitation of old masters a theme that has haunted all the artists of the 19th and 20th centuries at one time or another—including painters like Edouard Manet and Paul Cézanne, composers like Sergey Prokofiev and Igor Stravinsky, poets such as Jean Cocteau. The goals are always the same: to measure oneself against classical discipline, to understand a work more fully, and, finally, to break away. During the last years of his life, Picasso likewise engaged in a curious dialogue with the past when he painted fourteen variations of *The Women of Algiers,* forty-four of Velázquez's *Las Meninas,* and twenty-seven of Manet's *Déjeuner sur l'Herbe.*

In 1955 Picasso moved into a new home, the villa La Californie in Cannes. He turned the vast living room into a studio, thus transforming an overwrought, baroque setting into a place for painting. La Californie became a veritable storeroom into which were jumbled all the objects Picasso loved: paintings, sculpture, and furniture. Picasso painted some fifteen canvases based on this studio, which he called his "interior landscape." In the center of this painting, *The Studio of La Californie* (1956), a blank canvas is posed on an easel. To the right is a sketchy portrait of Jacqueline in Turkish dress. To the left, a small, lozenge-shaped sculpture, *Female Head,* and a Moroccan dish. Picasso used the cutout forms of the window borders as a decorative motif to give rhythm to his composition.

Viewers would be able to see a painting, *The Beach of La Garoupe,* be produced before their very eyes, as if by magic. Picasso himself, during the first screening of the film, was fascinated by the phenomenon! The film, *Le Mystère Picasso,* was a great success.

Picasso Bought the Marvelous Château de Vauvenargues, in the Heart of Cézanne Country

One day in 1958 Picasso telephoned his friend Kahnweiler to tell him, "I just bought the Mont Sainte-Victoire!" Thinking he was talking about one of the innumerable paintings Cézanne did of the mountain called Sainte-Victoire, Kahnweiler asked, "Which one?" Picasso had to convince him that he was not talking about a Cézanne canvas but a property of about 2000 acres around the old Château of Vauvenargues, located on the north slope of the mountain. The sale had taken place quickly. Perhaps unconsciously on the lookout for a quieter place to work—Cannes was becoming very popular—Picasso had discovered Vauvenargues while taking a walk. When he encountered the château, and the wild valley in which it stood, it was love at first sight.

Above: A photograph of the Château de Vauvenargues, near Aix-en-Provence, where Cézanne once lived and where Picasso spent time between 1958 and 1961.

In September 1958 Picasso moved into Vauvenargues with all his own canvases and those of all the painters who formed part of his collection: Paul Cézanne, Henri Matisse, Gustav Courbet, Paul Gauguin, Vincent van Gogh, and Henri Rousseau. He worked in the large drawing room, where the bust of a former marquis of Vauvenargues sat enthroned above the 18th-century fireplace. As was usual when he changed residences, Picasso's manner of painting changed. He rediscovered the land of Cézanne, a painter he had always loved. It pleased him to say, "I live at Cézanne's place."

He also rediscovered, suddenly rising from his inner depths, a dark Spanish vein that brought forth paintings that were severe and somber. He made portraits of Jacqueline in dark greens, blacks, and deep reds. On one of them he wrote: "Jacqueline de Vauvenargues."

On 2 March 1961 Picasso married Jacqueline Roque. The marriage took place in the greatest secrecy at the Vallauris town hall. For once the flood of curiosity-seekers and journalists was successfully evaded.

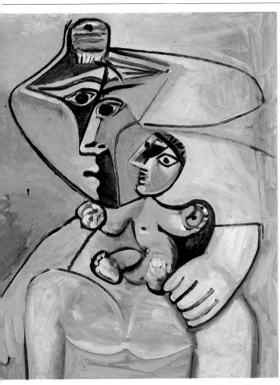

M*other and Child,* 1971. Maternity is a theme that reappeared often and strongly in Picasso's work. At the end of his life, at ninety, Picasso tried a new way of painting: Figures were summarily sketched out, "dripping" with rapid and obvious brushstrokes. More colors suddenly appeared on his canvas. This unfinished quality, seemingly born of negligence, was in reality the sign of a new vitality. The search, always beginning anew with Picasso, bore witness to a greater freedom in painting.

otre-Dame-de-Vie, the Last of "Picasso's Places"

he Vauvenargues château was an impressive site, wild
nd solitary. But it was a difficult place to live in all year
ound. Picasso's stays there grew shorter and shorter. And
ne day, in 1961, he found seclusion in a setting that was
ore livable, more human in scale than Vauvenargues—
a old Provençal country house with a beautiful name,
otre-Dame-de-Vie. Located on a hill near the small
llage of Mougins, it was isolated though not cut off
om the world; Cannes was only five miles away. Pablo
nd Jacqueline happily moved into its large, cool rooms.
 On 27 March 1963, on the last page of a notebook
lled with sumptuous drawings, Picasso noted, "Painting
 stronger than me, she makes me do her will." At
ghty-one he was still "inhabited" by painting, always

Picasso holding a praying mantis.

"I do not seek, I find."
Picasso

ushing a little farther, with the same ruthless demands. He worked at this age as he had at thirty—as if painting were life itself and life pushed him to it, and that to paint gave him back all the days of his life.

On 1 May 1970 a gigantic exhibition of Picasso's recent works—167 paintings and 45 drawings—took place in the Palais des Papes in Avignon. Those who viewed these later works were overwhelmed by this burst of energy: A new approach appeared in these pictures, there were new colors, new subjects! There were musketeers, men with swords, and matadors. Spain was resurfacing.

Thanks to Picasso's most faithful and devoted of friends, Jaime Sabartés, the Museo Picasso opened in Barcelona, in a splendid 15th-century palace in the heart of the old town. Before his death, in 1968, Sabartés had given his art collection to the newly formed museum. Picasso, too, gave Barcelona proof that it was the Spanish city dearest to his heart: He donated almost all the works of his youth to the museum.

In 1973 Picasso was ninety-one. Rooted in him as strongly as ever was the wish to provoke emotion, to cast light into obscure regions using color, form, image, symbol. He still had an unshakable faith in his power to create and to give the best and most accurate form to what was to be expressed. This tremendous vital power is what made his death seem so sudden.

Picasso died on 8 April 1973. The world was shocked. He had led people to believe he had held within him a light that could never be extinguished. As he often said, "Paintings are never finished.... They usually stop when the time comes because something happens that interrupts them."

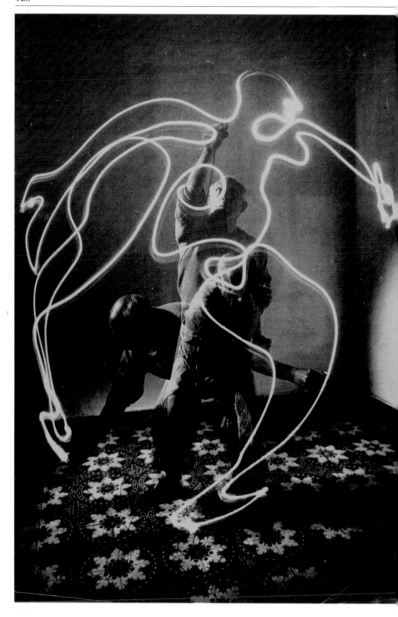

DOCUMENTS

Reminiscences, sketches, letters,
photographs, poems: Those who knew,
loved, and admired Picasso tell their stories.

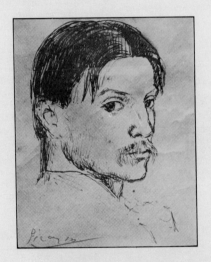

Recollections

Picasso seldom wrote about his work or his life. What he wanted to say, he said through his painting. But his close friends, his colleagues, and the women he loved and lived with witnessed his life and often described their encounters and conversations with Picasso in writing. These intimate accounts provide us with remarkably vivid documents of the painter's personality. In this way, we, too, can almost see him live, work, and speak.

F*lower-Woman,*
1946.

Françoise Gilot (b. 1921). A fellow painter, Françoise was Pablo's companion from 1943 to 1953. They had two children together, Claude (born in 1947) and Paloma (born in 1949).

That same day he began to paint the portrait of me that has come to be called *La Femme-Fleur.* I asked him if it would bother him to have me watch him as he worked on it.

"By no means," he said. "In fact I'm sure it will help me, even though I don't need you to pose."

Over the next month I watched him paint, alternating between the portrait and several still lifes. He used no palette. At his right was a small table covered with newspapers and three or four large cans filled with brushes standing in turpentine. Every time he took a brush he wiped it off on the newspapers, which were a jungle of colored smudges and slashes. Whenever he wanted pure color, he squeezed some from a tube onto the newspaper. From time to time he would mix small quantities of color on the paper. At his feet and around the base of the easel were cans—mostly tomato cans of various sizes —that held grays and neutral tones and other colors which he had previously mixed.

He stood before the canvas for three or four hours at a stretch. He made almost no superfluous gestures. I asked him if it didn't tire him to stand so long in one spot. He shook his head.

"No," he said. "That's why painters live so long. While I work I leave my body outside the door, the way Moslems take off their shoes before entering the mosque."

Picasso and Françoise Gilot at home in La Galloise in Vallauris, 1951.

Occasionally he walked to the other end of the atelier and sat in a wicker armchair with a high Gothic back that appears in many of his paintings. He would cross his legs, plant one elbow on his knee and, resting his chin on his fist, the other hand behind, would stay there studying the painting without speaking for as long as an hour. After that he would generally go back to work on the portrait. Sometimes he would say, "I can't carry that plastic idea any further today," and then begin work on another painting. He always had several half-dry unfinished canvases to choose from. He worked like that from two in the afternoon until eleven in the evening before stopping to eat.

There was total silence in the atelier, broken only by Pablo's monologues or an occasional conversation; never an interruption from the world outside. When daylight began to fade from the canvas, he switched on two spotlights and everything but the picture surface fell away into the shadows.

"There must be darkness everywhere except on the canvas, so that the painter becomes hypnotized by his own work and paints almost as though he were in a trance," he said. "He must stay as close as possible to his own inner world if he wants to transcend the limitations his reason is always trying to impose on him."

Françoise Gilot and Carlton Lake
Life with Picasso
1964

*Daniel-Henry Kahnweiler (1884–1979).
A writer, publisher, and historian of
German art, he was also Picasso's first
dealer. He opened his Paris gallery in
1907, exhibiting works by the avant-
garde of the era: Georges Braque, Henri
Matisse, and Pablo Picasso.*

KAHNWEILER:….So one day I set off. I
knew the address, 13 Rue Ravignan.
For the first time I walked up those
stairs on the Place Ravignan, which I
tramped up and down so many times
later, and entered that strange structure
that was later named "the laundry boat"
because it was made of wood and glass,
like those boats that existed then, where
housewives used to come to do their
washing in the Seine. You had to speak
to the concierge of the adjacent
building, for the house itself had none.
She told me that he lived on the first
flight down, for this house, hanging
on the side of the hill of Montmartre,
had its entrance on the top floor,
and one walked down to the other
floors. Thus I arrived at the door that
I had been told was Picasso's. It was
covered with the scrawls of friends
making appointments: "Manolo is at
Azon's…Totote has come…Derain is
coming this afternoon…"

I knocked on the door. A young
man, barelegged, in shirt sleeves, with
the shirt unbuttoned, opened the door,
took me by the hand, and showed me
in. It was the young man who had
come a few days before, and the old
gentleman he had brought with him
was Vollard, who, of course, made one
of his characteristic jokes about their
visit, telling everyone he knew that
there was a young man whose parents
had given him a gallery for his first
communion.

So I walked into that room, which
Picasso used as a studio. No one can
ever imagine the poverty, the deplorable
misery of those studios in Rue
Ravignan. Gris's studio was perhaps
even worse than Picasso's. The
wallpaper hung in tatters from the
unplastered walls. There was dust on
the drawings and rolled-up canvases on
the caved-in couch. Beside the stove was
a kind of mountain of piled-up lava,
which was ashes. It was unspeakable. It
was here that he lived with a very
beautiful woman, Fernande, and a huge
dog named Fricka. There was also that
large painting Uhde had told me about,
which was later called *Les Demoiselles
d'Avignon,* and which constitutes the
beginning of cubism. I wish I could
convey to you the incredible heroism of
a man like Picasso, whose spiritual
solitude at this time was truly terrifying,
for not one of his painter friends had
followed him. The picture he had
painted seemed to everyone something
mad or monstrous. Braque, who had
met Picasso through Apollinaire, had
declared that it made him feel as if
someone were drinking gasoline and
spitting fire, and Derain told me that
one day Picasso would be found
hanging behind his big picture, so
desperate did this enterprise appear.

Everyone who knows the picture
now sees it in exactly the same state it
was in then. Picasso regarded it as
unfinished, but it has remained
exactly as it was, with its two rather
different halves. The left half, almost
monochrome, is still related to the
figures from his rose period (but here
they are hacked out, as they used to say,
modeled much more strongly), whereas
the other half, very colorful, is truly the
starting-point of a new art.

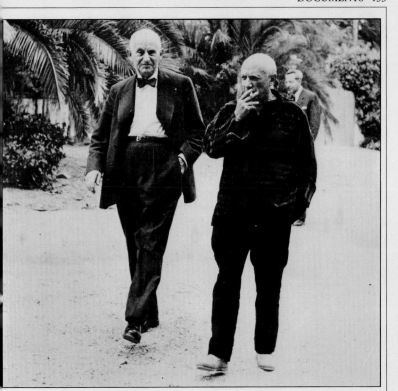

Kahnweiler and Picasso at La Californie in the 1960s.

CREMIEUX: Did you discuss *Les Demoiselles d'Avignon* with Vollard?

KAHNWEILER: Oh, I hardly ever saw Vollard in those days. I did not meet him until later. Vollard very rarely came to Picasso's studio. But I know that at that time Vollard did not appreciate what Picasso was doing since he did not buy from him any more, which is the best proof that he didn't like his work. Vollard had certainly seen *Les Demoiselles d'Avignon,* which he must have disliked excessively, as did everyone else at the time.

CREMIEUX: Do you remember your first conversation with Picasso in front of that picture?

KAHNWEILER: No, I don't; I only remember that I must have told him immediately that I found his work admirable, for I was overwhelmed.

Daniel-Henry Kahnweiler
with Francis Crémieux
My Galleries and Painters
Translated by Helen Weaver
1971

Brassaï (Gyula Halász, 1899–1983).
A photographer of Hungarian origin,
Brassaï moved to Paris in 1923. He
made several celebrated portraits of
Picasso and photographed his sculptures,
usually without incident.

Tuesday, 30 November 1943
….Today I set to work on a major task:
L'Homme à l'Agneau [*Man with a
Sheep*]. The fanatical eyes of this "good
shepherd" are fixed unswervingly on
me. He weighs a great deal. There is no
question of moving him. I can do no
more than turn him on his axis. And
how am I to find a suitable backdrop?
And how am I to light him? Standing in
dead center of the room, he is
completely in shadow.

Picasso comes into the studio,
engaged in a lively conversation with a
man of commanding appearance,
elegantly dressed, and superbly bald.
He introduces us. I catch only the first
name, which Picasso never stops
repeating, as a matter of fact: Boris,
Boris…Boris is extremely attentive to
the lighting I am trying to set up for
L'Homme à l'Agneau. He smothers me
with advice. "Do this…" "Don't do
that…" "It would be better if you lit it
like this…" His persistence annoys me.
It also annoys Picasso, who intervenes:
"You're wasting your time, Boris.
Brassaï knows very well what he is
doing. And your experience with
footlights is of no use to him at all…"

I am left alone with the shepherd,
who is giving me a good deal more
trouble than the other statues. I take
several photographs, full face, from a
three-quarter angle, and in profile.
Each time, when I must turn him
around, I hold him carefully by the
waist, because the ewe lamb he is

carrying is very fragile, and leaps
nervously in his arms…I have almost
finished. But before I leave him, I want
to turn him just one more time—
perhaps I will glimpse an angle I have
not seen before…I take him between
my hands and, very gently, begin the
revolving motion. He has turned
perhaps a quarter of the circle when I
hear a dry, cracking sound, and one of
the feet of the lamb falls and breaks
into several pieces on the pedestal. The
foot that was free of the shepherd's
arms, thrust out adventurously…

For a long time now I have been
expecting and fearing this accident. I
knew that it must happen some day,
fatally, inevitably. In three months that I
have been lifting, turning, pushing and
pulling at all of Picasso's sculptures,
standing them on improvised, unstable
pedestals—and most of the time
carrying out these risky maneuvers with
no help at all—it is a miracle that I had
not yet broken any of them…

Once my first emotion has passed, I
decide to tell Picasso what has
happened. I know that he considers
L'Homme à l'Agneau one of his most
important works, and rightly so. What
will his reaction be? He is certainly
going to fly into one of those violent
black rages which, personally, I have
never had occasion to face. Perhaps it
would be preferable to tell Sabartés first,
and soften the blow? But I haven't seen
him this morning. As I examine the
debris of the foot, I realize that it was
not very solidly attached to the body.
The nail that was meant to hold it in
place had cracked the plaster. The
slightest shock would have caused it to
fall. It was inevitable…And the
Nemesis of sculpture whispers in my
ear: "I tolerate nothing that ventures

Brassaï photographing the night, a self-portrait from the 1930s.

imprudently far from its base…I
decapitate, amputate, mutilate…I wear
away fingers, noses, ears, the legs of
Hercules and the arms of Venus,
anything that separates itself from the
trunk…Huddled into itself, offering no
projecting points to the weather or the
winds, to vandals or photographers,
resembling a crouching insect with all
of its limbs in hiding, pretending to be
dead—this is what I have decreed for
sculpture…" I offer up the objection
that this statue was meant to be cast in
bronze, which allows for everything….

 I announce the news to Picasso. He
doesn't shout, he doesn't explode. I see
no flames in the nostrils of the
minotaur. Could this be a bad sign?
Haven't I been told that his cold furies,
when he turns white with concentrated
rage, are even more dangerous than
those where everything happens
immediately? He follows me, without
having said a word. It is as a technician,
an expert in his field, that he examines
the wreckage. The pieces are fairly
large, and none of them are missing. He
has seen the nail, and the crack. "It isn't
very serious," he says to me, calmly.
"The socket was not deep enough. I'll
redo it one of these days."

 In the meantime, Sabartés has come
back. Picasso tells him about the
accident.

SABARTÉS: I know why you broke it. So that other photographers couldn't take a picture of it…And you are perfectly right! You should break every single one of Picasso's statues, as soon as you have photographed it. Do you realize how valuable the pictures would be?

An hour later, as I am leaving, Picasso says: "I wasn't angry, was I?"

Brassaï
Picasso and Company
Translated by Francis Price, 1966

André Malraux (1901–1976). Writer Malraux's involvement with the International Brigade that fought for Republican Spain in 1936 combined with his love of art made him a perfect liaison for Picasso. As France's Minister of Culture in 1966, he organized a large Picasso exhibition in the Grand Palais in Paris.

One of the casts was of the mutilated statuette. The other was one he had found of the restored statuette: her bust,

André Malraux.

and her legs joined together, sprang forth symmetrically from the lusty volume of her rump and her belly.

"I could make her by taking a tomato and piercing it through with a spindle, right?"

There were also some of his engraved pebbles, some of his small bronzes, a copy of his *Glass of Absinthe*, and the skeleton of a bat. He took a *Cretan Woman* from one of the shelves and held it out to me. The photographs of her did not convey all the sharply cut detail.

"I made them with a small knife."

"Ageless sculpture…"

"That's just what we need. We also need painters who will paint ageless paintings. Modern art must be killed. So that another form may come into being.…

"People say, 'We love everything that resembles us.' But my sculpture is not a bit like it—not a bit like my idol! Is Brancusi the only one who should love it? Similarities! In *Les Demoiselles d'Avignon* I wanted a nose in profile within a full-view face. (It had to be put in sideways so that I could name it, so that I could call it a 'nose.') Then everybody talked about the Negroes. Have you ever seen any piece of Negro sculpture—any one at all—with a nose in profile within a full-face mask? We all love the prehistoric paintings, but no one resembles them!"

At the time he was painting *Guernica* he had told me, in that very same studio, "It wasn't the forms of the fetishes that influenced me; what they did was make me understand what I expected from painting."

He was holding the violin-shaped idol from the Cyclades and looking at it. His face, which generally expressed surprise,

again changed into the intense mask it had become earlier, when he had looked at the photographs. An instantaneous transformation. Telepathic. (Braque had spoken to me about his "sleepwalking side.") He made no gesture; he went on talking. Neither the light nor the atmosphere had changed; there were still noises coming in from the street. But he was suddenly in a state of anguish and sadness, and it was infectious. I listened to him, and I heard some words he had once spoken at the time of the Spanish Civil War: "For us Spaniards there's Mass in the morning, bullfights in the afternoon, and brothels at night. What does that become all mixed up with? With sadness. A peculiar sadness. Like the Escorial. Yet I'm a gay sort of man, right?"

André Malraux
Picasso's Mask
Translated by June Guicharnaud
1976

Christian Zervos (1889–1970). Writer, art dealer, and publisher, in 1926 Zervos created the magazine Cahiers d'Art (Art journals), *which over the years printed numerous texts about Picasso and his work, as well as interviews with and writings by the artist himself, including the following thoughtful essay from 1935.*

I behave with my painting as I behave with things. I make a window the way I look through a window. If this open window does not look good in my picture, I pull a curtain across it and close it, as I would do in my room. You have to act with painting as you do in life, directly. Of course, painting has its conventions, which you must take into account, because you cannot do otherwise. For that reason, you must constantly have the presence of life in front of your eyes.

The artist is a receptacle of emotions that come from all over: from the sky, the ground, a piece of paper, from a figure that passes, from a spiderweb. That is why you should not make distinctions between things. For things, there are no privileged neighborhoods. You have to take what you can where you find it, except in one's own work. I have a horror of copying myself, yet I do not hesitate, when presented with a box of old drawings, for example, to take from them anything I want....

The painter experiences states of fullness and emptiness. There you have the secret of art. I take a walk through Fontainebleau forest. I leave with a surfeit of green. I must evacuate this sensation onto a canvas. There, green dominates. The painter makes the painting in an urgent need to discharge sensations and visions. People take hold of it to clothe their nakedness a bit. They take what they can, the way they can. In the end, I believe, they do not take anything, they simply tailor the clothing to the size of their incomprehension. They make everything in their own image, from God all the way to a painting. That is why the screw eye [the hardware used for picture hanging] is the destroyer of paintings. Paintings have importance, at least to the person who made them. The day when they are bought and hung on the wall, they take on the importance of another space, and the painting is ruined.

Academic teaching about beauty is false. We have been lied to, but lied to

so well that you can no longer relocate even the shadow of the truth. The beauties of the Parthenon, the Venuses, the Nymphs, Narcissus, are so many lies....

Everyone wants to understand painting. Why not try to understand the songs of birds? Why can people love a night, a flower, all that surrounds humankind, without seeking to understand it? Yet with painting, people want to understand. If they could understand that the artist works out of necessity; that he, too, is a lowly element in the world, to which one must not lend any more importance than one does the other things in nature that charm us but that we do not explain. Those who seek to explain a painting are most of the time on the wrong track. Gertrude Stein announced to me, some time ago, that she had finally understood what my painting *Three Musicians* represented. It was a still life!

Christian Zervos
Cahiers d'Art, 1935

Hélène Parmelin. Writer and wife of painter Edouard Pignon. Both were great friends of Picasso and his wife Jacqueline during the 1950s.

Painting Is Not Inoffensive

Regarding that irritating habit that some have of considering painting, in the final analysis, as being of no consequence, as an "animal that is not dangerous," Picasso exclaims: "Be very careful about that. It's all very well, it's very nice to do a portrait with all the buttons on the clothing, and even the buttonholes, with the little reflection on the button. But watch out!... The moment may come when those buttons

start to leap out into your face....

"You have to pay a good deal of attention to what you are doing. Because it is when one feels the least free that one is sometimes the freest! And not at all when one feels one has the wings of a giant, which may prevent one from walking."

When at Vallauris he painted *Little Girl Skipping Rope,* he began by painting the canvas. The ground was marked with a small line.

Or rather the shade.

He received, not too long ago, a bronze cast of the sculpture that he made from that same painting and which is at Notre-Dame-de-Vie.

When he was assembling the elements, it was the sculpture that became the major research into reality. The problem of how to deal with a little girl in the air was not one that would exasperate a painter.

But a sculptor has to find a way to approach it. How? One day, Picasso appeared, completely cheerful. He had just been working with *Little Girl Skipping Rope*'s spatial problem. "I realized," he said, "what I should rest the little girl on when she is in the air. On the rope, naturally! How could I have not thought of it:...You only have to look at reality…"

Never Without the Opposite

The Picasso phrase most often quoted is: "I do not seek. I find."

A marvel of audacity, it can only be explained, if indeed he ever said it, by the demonstration of its opposite.

"One never stops seeking because one never finds."

In reality, he found at every turn, he sought at every turn. He had barely finished one canvas when he would look

at it to ferret out the secrets that he had just himself put there. And he would begin another, which would take him where he did not want to go, just as he took it where it did not want to go. And so on....

The Chains of Liberty

"Freedom," said Picasso, "You have to be very careful with it. In painting as in everything else. No matter what you do you find yourself back in chains. The freedom to not do one thing demands that you do another, by necessity. And, *voilà*, there you have chains. It deceives, with the same words, because it is completely something else and often the opposite."

He added: "Jacqueline says that speaking is like sewing seeds. Sometimes the seeds germinate and flower, sometimes they perish."

Finishing a Painting

Real painters can never rest on their laurels. They can only live the eternal and terrible life of painters, waging the war of painting up to the very end. A painter is never satisfied.

"But the worst of all," Picasso said, "is that one is never finished. There is never a moment where you can say: I have worked well, and tomorrow is Sunday. As soon as you stop, it is only to start again. You put aside one canvas telling yourself you will not work on it any more. But you can never add THE END."

Hélène Parmelin
Picasso Says, 1966

A still from the film *Le Mystère Picasso,* directed by Henri-Georges Clouzot, 1955.

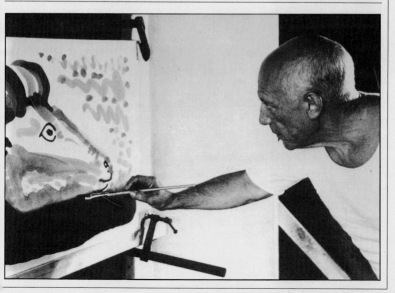

John Richardson. Here art critic Richardson recounts a meeting with Picasso in the mid-1950s.

Treasure or Rubbish?

Some twenty-five years ago, Picasso had the contents of his Paris studio shipped to the villa he had recently bought at Cannes. Among the treasures, household goods, and accumulated rubbish—the artist was a compulsive hoarder—were some seventy portfolios. The day Picasso decided to go through these, I happened to be present. Few had been opened since 1939, some not since 1914. Although Picasso was vague about what was in the portfolios, there was reason to believe that they contained most of the works on paper that he had kept for himself, because they were too precious, personal, exploratory, or else too scabrous to exhibit, let alone put on the market.

And here we should bear in mind that, as he grew older, Picasso retained much of his best work, drawings especially. So it was with the trepidation felt by Howard Carter when the first pick-axe probed Tutankhamen's burial chamber that we watched Picasso fiddle tantalizingly with the knots.

Picture our dismay when the artist threw open a bulging portfolio and gleefully showed us sheet after sheet of paper, some of it to be sure emanating from eighteenth-century Italy or nineteenth-century Japan, but all uniformly blank. "Far too good to use"—the artist knew he could count on our emphatic denials. Was Picasso up to one of his celebrated teases?... No, the next portfolio contained Ingresque portrait drawings, many of them

unpublished, of family and friends; another disgorged papiers collés, some not even glued together, and so forth....

As Picasso scanned his own drawings, I could not help being struck by his total concentration, at the same time scary detachment about himself. It was as if he were examining work he had never seen before by an artist quite unknown to him.... "Not bad," he would comment, but more in the spirit of a teacher going over a student's work than in pride of execution or ownership. "Wouldn't the [New York] Museum of Modern Art like to get their hands on all this for their up-and-coming show?" (this was in 1956), Picasso grinned malevolently. "This is what *I* call a retrospective," and all of a sudden he made a great to-do about locking everything away....

Five Factors of Style

The facts of his life have more bearing on Picasso's art than is the case with any other great artist, except perhaps Van Gogh. The more we know about his day-to-day existence and particularly his domestic arrangements, the easier it is to unravel the mysteries and metamorphoses of Picasso's development. This is especially true after 1918, when abrupt changes in style imply that one wife or mistress has been substituted for another. Thus the pattern of stylistic infidelity can be said to follow the pattern of amorous infidelity.... In no other great life are the minutiae of gossip so potentially significant.

Dora Maar, probably the most perceptive of the artist's companions, once told me that at any given period of the artist's post-Cubist life there were five factors that determined

his way of life and likewise his style: the woman with whom he was in love; the poet, or poets, who served as a catalyst; the place where he lived; the circle of friends who provided the admiration and understanding of which he never had enough; and the dog who was his inseparable companion and sometimes figured in the iconography of his work. On occasion these factors overlapped: Jaime Sabartés, Picasso's secretary, survived four different régimes. But as a rule, when the wife or mistress changed, virtually everything else changed.

John Richardson,
from *A Picasso Anthology:*
Documents, Criticism, Reminiscences,
Edited by Marilyn McCully, 1981

Gertrude Stein (1874–1946). An
American writer who was introduced to
Picasso in Paris in 1905, Stein later
authored two books about the painter:
Picasso and Gertrude Stein (1932) and
Picasso (1938).

Once again Picasso in 1909 was in Spain and he brought back with him some landscapes which were, certainly were, the beginning of cubism. These three landscapes were extraordinarily realistic and all the same the beginning of cubism. Picasso had by chance taken some photographs of the village that he had painted and it always amused me when every one protested against the fantasy of the pictures to make them look at the photographs which made them see that the pictures were almost exactly like the photographs....

After his return from Spain with his first cubist landscapes in his hand,

1909, a long struggle commenced.

Cubism began with landscapes but inevitably he then at once tried to use the idea he had in expressing people. Picasso's first cubist pictures were landscapes, he then did still life but Spaniard that he is, he always knew that people were the only interesting thing to him. Landscapes and still lifes, the seduction of flowers and of landscapes, of still lifes were inevitably more seductive to Frenchmen than to Spaniards, Juan Gris always made still lifes but to him a still life was not a seduction it was a religion, but the ecstasy of things seen, only seen; never touches the Spanish soul.

The head the face the human body these are all that exist for Picasso. I remember once we were walking and we saw a learned man sitting on a bench, before the war a learned man could be sitting on a bench, and Picasso said, look at that face, it is as old as the world, all faces are as old as the world.

And so Picasso commenced his long struggle to express heads faces and bodies of men and of women in the composition which is his composition. The beginning of this struggle was hard and his struggle is still a hard struggle, the souls of people do not interest him, that is to say for him the reality of life is in the head, the face and the body and this is for him so important, so persistent, so complete that it is not at all necessary to think of any other thing and the soul is another thing.

The struggle then had commenced.

Gertrude Stein,
from *A Picasso Anthology:*
Documents, Criticism, Reminiscences,
Edited by Marilyn McCully, 1981

Picasso and Poetry

From his arrival in Paris until the end of his life, Picasso maintained rich and long-lasting friendships with some of the greatest writers and poets of the 20th century, including Max Jacob, Guillaume Apollinaire, Jean Cocteau, André Breton, and Paul Eluard. Eluard (1895–1952), one of the literary inventors of Surrealism, was a good friend and supporter of Picasso's from the early 1930s until Eluard's death. Between 1936 and 1939, Picasso illustrated a number of books and poems by the author.

A Poet Before a Picture

Among the men that have most fully established their lives, of whom it cannot be said that they have passed along the earth without at once the thought that they will remain, Pablo Picasso stands with the very greatest. After having subjected the world, he had the courage to turn it against himself, sure that it would be not to conquer, but to find himself its size. "When I have no blue, I use red," he has remarked.

Instead of a single straight line or a curve, he has broken a thousand lines that within him find their unity again, their truth. Scorning the accepted notions of objective reality, he has reestablished the contact between the object and the one that beholds it and that, consequently, thinks it; he has given us once more, in the most audacious, the most sublime, fashion, the inseparable proofs of the existence of man and of the world.

Beginning with Picasso, the walls crash down. The painter renounces his reality no more than the reality of the world. He is before a poem as the poet before a picture.

He dreams, he imagines, he creates. And suddenly, behold, the potential object is born from the real object, and it in its turn grows real; behold, they form an image, from the real to the real, as one word with all the rest. One is no longer at a loss about the object, since all fits in, binds together, takes on value, takes its own place. Two objects separate only to find one another more fully in their remoteness, running the gamut of all beings.

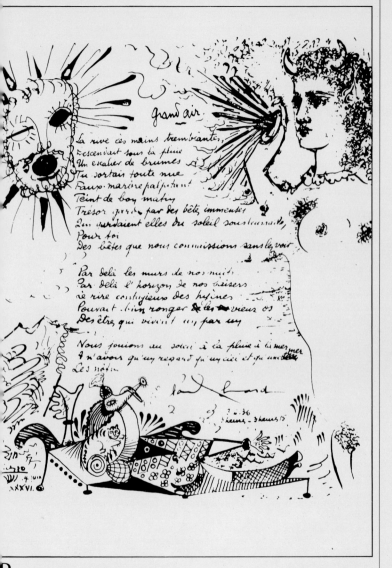

Picasso's illustration of an Eluard poem, 1936.

To Pablo Picasso

I

Some have invented boredom others laughter
Certain ones fit life with a cloak of storm
They swat butterflies spit birds before the fire
And go off to die in the dark

You you have opened eyes that go their way
Amid natural things in every age
You have made harvest of natural things
And you sow for all times

They preached at you body and soul
You have put the head back on the body
You have pierced the tongue of the satiate man
You have burned the blessed bread of beauty
A single heart quickens the idol and its slaves
And amid your victims you continue to work
Innocently

There's an end of joys engrafted on sorrow.[…]

III

An end of going astray anything can be
Since the table is straight as an oak
Color of monk's cloth color of hope
Since in our field small as a diamond
Is held the reflection of all the stars

Anything can be we are friends of man and beast
After the fashion of the rainbow

By turns fiery and frigid
Our will is of mother-of-pearl
It changes buds and blossoms not

according to the hour but according
To the hand and the eye that we knew not ourselves
We shall touch everything we see
As well as the sky as woman
We join our hands to our eyes
The holiday's new.

IV

The bull's ear at the window
Of the wild house where the wounded sun
An inner sun takes to earth

Tapestries of awakening the walls of the room
Have conquered sleep.

V

Is there a clay more sterile than all these torn newspapers
With which you set forth to conquer the dawn
The dawn of an humble object
You design lovingly that which awaits its being
You design in the void
As folk do not design
Generously you cut out the form of a chicken
Your hands played with your tobacco pouch
With a glass a bottle that gained

The infant world came out of a dream
Good wind for guitar and for bird
A single passion for the bed and the barque
For fresh pastures and for wine that's new

The legs of the bathers bare the waves and strand
Morning your blue shutters close upon the night

In the furrows the quail smells of
hazelnuts
Of olden Augusts and of Thursdays gone
Pied harvests full-voiced peasant women
Shells of the marshlands dryness of the
nests

Countenance of bitter swallows in the
raucous sunset

The morning kindles a green fruit
Gilds the grainfields cheeks hearts
You hold the flame between your fingers
And paint like a conflagration
At length the flame unites at length the
flame brings salvation.

VI
I recognize the changing image of the
woman
Double star moving mirror
Negatress of the desert and of forgetfulness
Source with breasts of heather spark trust
Giving daylight to the day and her
blood to blood
O hear you sing her song

Her thousand fancied forms
Her colors that make the bed of the
countryside
Then go off to hue mirages of night

And when the caress takes flight
Immense violence remains

Insult remains with weary wings
Gloomy metamorphosis a lonely people
Whom ill-luck devours

Drama of seeing where there is nothing
to see
Save oneself and what is like oneself

You cannot wipe yourself away
All is reborn beneath your even eyes

And on the basis of present memories
Without order nor disorder with
simplicity
Rises the prestige of giving sight.

Paul Eluard
Pablo Picasso
Translated by Joseph T. Shipley, 1947

Picasso and Eluard in 1936.

Picasso, Writer

Picasso once told a friend that he believed one day encyclopedias would say, "Picasso, Pablo Ruiz—Spanish poet who dabbled in painting, drawing, and sculpture." Picasso did, in fact, write several plays—including Desire Caught by the Tail, *Act VI of which is printed here—and many poems, two of which appear on pp. 150–1. His colorful poems often incorporate drawings and ink blots.*

[*The scene takes place in the sewer bedroom kitchen and bathroom of the* ANGUISHES' *villa.*]

SKINNY ANGUISH: The burn of my unhealthy passions irritates the soreness of the chilblains which are enamored of the prism permanently set up on the bronze-colored angles of the rainbow and evaporates it into confetti. I am only the congealed soul stuck to the panes of the fire. I beat my portrait against my brow and hawk the merchandise of my grief at the windows which are closed to all mercy. My shirt, torn to shreds by the rigid fans of my tears, bites with the nitric acid of its blows, the sea-weed of my arms dragging the dress of my feet and my cries from door to door. The little bag of pralines which I bought from Big Foot yesterday for 0 francs 40 centimes is burning my hands. A purulent fistula in my heart, love is playing marbles between the feathers of its wings. The old sewing-machine which turns the horses and the lions of the disheveled merry-go-round of my desires chops up my sausage flesh and offers it alive to the icy hands of the still-born stars which are rapping their wolfish hunger and their oceanic thirst at my window-panes. The enormous pile of logs are awaiting their fate with resignation. Let's make the soup. [*Reading from a cook-book:*] A half-quarter of Spanish melon, palm oil, lemon, kidney-beans, salt, vinegar, bread-crumbs; cook with a low flame; from time to time delicately take a soul in agony out of purgatory; cool it; reproduce a thousand copies on imperial Japanese vellum and allow to

A page of manuscript from *Desire Caught by the Tail*, 1941.

Friends assembled for a reading of *Desire Caught by the Tail* in 1944. Picasso stands in the center. To his right are Zanie Aubier, Louise Leiris, Pierre Reverdy, Cécile Eluard, and Dr. Jacques Lacan; to his left, Valentine Hugo and Simone de Beauvoir. Jean-Paul Sartre, Michel Leiris, and Jean Aubier are seated. Albert Camus is squatting.

chill long enough to be able to give it to the octopuses. [*Crying from the manhole of their bed:*] Sister! Sister! Come here! Come help me set the table and fold the dirty linen spotted with blood and excrement! Hurry up, sister, the soup's already cold and is cracking at the bottom of the glass of the mirror-wardrobe. The whole afternoon I've been embroidering a thousand stories about that soup that she's going to tell you secretly in your ear, if you want to

keep for the end the architecture of the skeleton's bouquet of violets.

FAT ANGUISH: [*uncombed and filthy dirty, getting out of the sheets of the bed which is full of fried potatoes, holding an old frying-pan in his hand*] I've come a great distance and dazzled by the long patience that I had to follow behind the hearse of the carp-leaps which the big-shot dyer who's so scrupulous about his accounts wanted to lay at my feet.

SKINNY ANGUISH: The sun.

FAT ANGUISH: Love.

SKINNY ANGUISH: You're so lovely!

FAT ANGUISH: When I left the sewer of our house this morning, immediately, two steps from the gate, I took my pair of hobnailed boots off my wings, and, leaping into the icy pond of my griefs, I let myself be dragged by the waves far from the banks. Lying on my back, I stretched out on the scum of this water and I kept my mouth open for a long time in order to catch my tears. My closed eyes also caught the crown of that long rain of flowers.

SKINNY ANGUISH: Dinner is served.

FAT ANGUISH: Hurray for joy, love, and springtime!

SKINNY ANGUISH: Go carve the turkey and take plenty of stuffing. The big bouquet of horrors and frights is already waving farewell. And the mussel shells are clacking their teeth, scared to death under the icy ears of boredom. [*She takes a piece of bread which she soaks in the sauce.*] This hash needs salt and pepper. My aunt had a canary which used to sing old drinking-songs all night long.

FAT ANGUISH: I'm taking some more sturgeon. The pungent flavor of these dishes keeps my depraved tastes for spicy and indigestible foods in a state of high suspense.

SKINNY ANGUISH: I just found the lace dress I wore at the white ball given on the baleful day of my name-day all moth-eaten and full of spots on top of the closet in the lavatory, writhing in inflamed pain beneath the dust of the tick tock of the clock. It's certainly our housekeeper who put it there the other day to go see her boy-friend.

FAT ANGUISH: Look, the door is running forward. There's someone inside who's coming in. The postman? No, it's Tart. [*Addressing* TART.] Come in. Come have tea with us. How pleased you must be. Tell us the news about Big Foot. Onion arrived this morning pale and drawn, soaked with urine and wounded, with his forehead pierced through and through by a pickaxe. He was crying. We attended to him and consoled him as well as we could. But he was in pieces. He was bleeding everywhere and was screaming incoherent words like a lunatic.

SKINNY ANGUISH: You know, the cat had her kittens last night.

FAT ANGUISH: We drowned them in a hard stone, to be exact, in a beautiful amethyst. The weather was fine that morning. A bit cold, but warm just the same.

TART: You know, I met love. He has scraped knees and he begs from door to door. He doesn't have a sou and is looking for a job as ticket-collector on a suburban bus. It's sad, but go help him…he's turning around and stinging you. Big Foot wanted to have me and he's the one who got caught in the trap. Look: I stayed out in the sun too long. I'm covered with blisters. Love. Love. Here's a five-franc piece, change it into dollars for me and keep the crumbs of small change. Good-bye! Forever! Happy holiday, friends! Good night! Top o' the morning! Happy New Year and farewell! [*She lifts up her skirt, shows her behind, and laughing leaps with*

one bound through the window breaking all the panes.]

FAT ANGUISH: A beautiful girl, intelligent, but bizarre. All this is going to come to no good end.

SKINNY ANGUISH: Let's call all these people. [*She takes a trumpet and blows assembly. All the characters in the play come running up.*] You, Onion, step forward. You have a right to six drawing-room chairs. Here they are.

ONION: Thank you, Madame!

FAT ANGUISH: You, Big Foot, if you can answer my questions, I'll give you the hanging lamp in the dining-room. Tell me how much are four and four?

BIG FOOT: Much too much and not a great deal.

SKINNY ANGUISH: Very good!

FAT ANGUISH: Very good!

SKINNY ANGUISH: [*uncorking a bottle and putting it under his nose*] What does that smell of? [**ROUND END** *laughs.*]

SKINNY ANGUISH: Very good! You understood. Here's a box full of pens. They're for you. And good luck.

FAT ANGUISH: Tart, give us your accounts.

TART: I've got six hundred quarts of milk in my sow tits. Ham. Tripe. Salami. Blood sausage. And my hair covered with chipolatas. I've got mauve gums, sugar in my urine, and my gouty hands full of the white of eggs. Bony cavities. Bile. Chancres. Fistulas, Scrofula. And lips twisted with honey and marshmallows.

Decently dressed, clean, I wear with elegance the ridiculous clothes that are given to me. I'm a mother and a perfect whore and I can dance the rhumba.

SKINNY ANGUISH: You get a can of gasoline and a fishing-rod. But first, you have to dance with all of us. Start with Big Foot. [*The music plays and they all dance changing from partner to partner every moment.*]

BIG FOOT: Let's wrap the worn out sheets in the angels' face powder and let's turn the mattress inside out in the brambles. Let's light all the lanterns. Let's throw the flights of doves against the bullets with all our might and let's close the houses that have been demolished by the bombs, with a double lock.

[*All the characters stop moving on both sides of the stage. Opening the window at the back of the room with a single movement, a golden sphere as tall as a man enters. He lights up the whole room and blinds the characters, who take handkerchiefs out of their pockets and bandage their eyes and, stretching out their right arms, point at one another, all crying out at the same time and several times:*] You! You! You!

[*On the big golden sphere appear the letters of the word:*]

Nobody.

Curtain.

Translated by Bernard Frechtman
1948

Overleaf: Manuscripts of two poems, dated 14 December 1935 and 15 June 1936.

14 Décembre XXXV.

sur le dos de l'immense tranche
de melon ardent
arbre morceau de fleuve
table à rire
sous la menace de l'air qui
serre pour le plaisir de voir
expirer entre ces dents
distraite de son ennui
un brin d'herbe
au deux petits boutons de prunus
tombées si bas
s'embrasent depuis deux ou trois jours
énervées par les pleurs
de la petite fille

Picasso as Illustrator

Picasso's keen sense of line, color, and design and his love of letters, printed text, and calligraphy often prompted him to put his talents to the service of illustration. Magazine covers, posters, prints: There were few areas of graphic design that he did not investigate. In certain cases, his prints served as illustrations for older texts, such as Metamorphoses, *by Ovid, a 1st-century Roman poet, or* Histoire Naturelle, *by 18th-century French naturalist Comte de Buffon. In others, he included the poem itself, ornamenting it with graphics to punctuate the text and give the work a visual strength and rhythm.*

Magazine cover illustrations made in 1933 (right above), 1966 (right below), and 1951 (opposite); exhibition posters from 1939 and 1956 (pp. 154–5); and illustrations from a 1942 edition of Buffon's *Histoire Naturelle* (pp. 156–7).

BALLETS RUSSES
DE DIAGHILEW
1909 - 1929

MARS - AVRIL 1939

MUSÉE DES ARTS DÉCORATIFS
Palais du Louvre _ Pavillon de Marsan, 107, rue de Rivoli

ENTRÉE 6 FRANCS

LE PIGEON

Picasso and the Theater

The theater provides a rich and original means of expression for painters: Painting is translated to the stage space; a sense of color and formal invention is harnessed to create costumes; one's aesthetic sense is placed in harmony with the text and music. It was Picasso's friend Jean Cocteau who persuaded him to design stage sets and costumes for the Ballets Russes, Sergey Diaghilev's troupe. Between 1917 and 1924, he was engaged in the production of several ballets, including Parade, The Tri-Cornered Hat, Mercure, *and* Pulcinella. *Here Cocteau recalls the process of creating* Parade *with Erik Satie and Picasso.*

My dear friend,

You asked me to tell you a few details about *Parade*. Here they are, all too briefly. Excuse my style and disorderliness.

Each morning I would experience new injuries, some from far afield, as critics unleashed themselves against us without having seen or heard the work; and as you can't fill up an abyss, as you would have to start all over again from Adam and Eve, I found it more dignified never to respond. Thus I would view with the same astonishment the article where we were insulted, the article where we were scorned, the article where forbearance competed with ridicule, the article where we were congratulated out of total lack of comprehension.

Facing this pile of myopic, uncultivated, insensitive louts, I thought back to the admirable months where we—Satie, Picasso, and I—had loved, searched, sketched, and combined little by little this tiny thing, so full, whose modesty, as a matter of fact, lay in its very lack of aggressiveness.

The idea came to me when I was on leave in April 1915 (I was then in the service) when listening to Satie play his *Pieces in the Shape of a Pear* four-hands with Viñes. The title is misleading. His posture as a humorist, dating back to Montmartre, prevents the heedless public from hearing the music…as it should be heard.

A kind of telepathy was to inspire in us the desire to collaborate. A week later, I returned to the front, leaving Satie with a pile of notes, drafts, which furnished him with the theme of the Chinaman, the young American girl, and the Acrobat (the acrobat at that time was alone). These directions had

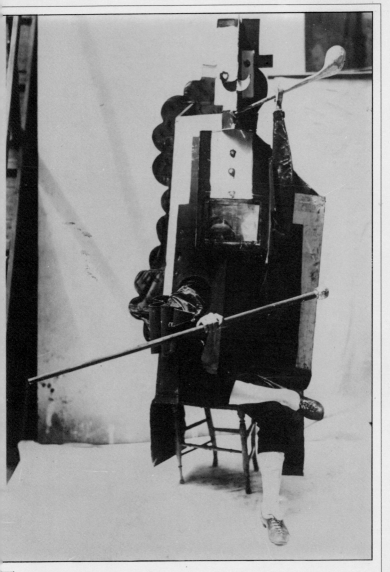

The Manager of Paris, a character in *Parade*.

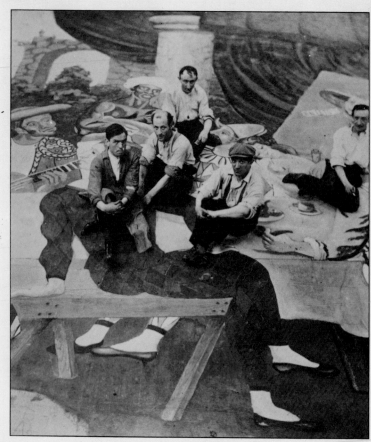

Picasso and workers sitting on the drop curtain for *Parade*.

nothing humorous about them. On the contrary, they stressed the extension of these characters, onto the backside of our street-fair booth. Thus, the Chinaman was capable of torturing missionaries, the young girl of drowning on the *Titanic*, and the acrobat of being a confidant of the angels.

Little by little, a musical score was developed in which Satie seemed to have discovered an unknown dimension, thanks to which one could hear simultaneously the parade and the internal spectacle.

In the first version, the Managers didn't exist. After each Music-Hall

umber, an anonymous voice, emerging from a kind of megaphone (a theatrical imitation of the street-fair gramophone, an antique mask done in modern style) would sing a characteristic phrase, summing up the character's point of view, allowing a glimpse of his dreams.

When Picasso showed us his sketches, we saw it would be interesting to link the three chromolithographs with characters that would be inhuman, superhuman, with a weightier transposition, who would become, finally, the false reality on stage, reducing the actual dancers to something on the order of puppets.

Thus I imagined the Managers as fierce, uncouth, vulgar, rowdy, harmful to those in their charge, and soliciting hatred (which in fact happened), laughter, and shrugs of the shoulders from the crowd, due to the oddness of their appearance and behavior.

During this phase of *Parade*, three actors seated in the orchestra would shout demands using loudspeakers....

Next, in Rome, where we went with Picasso to join Leonide Massine to combine stage sets, costumes, and choreography, I noticed that a single voice, even amplified, in the service of one of Picasso's Managers, was grating, creating an intolerable lack of balance. We would have needed three tones per Manager, which would have taken us far away from our principle of simplicity.

That was when we substituted for the voices the rhythm of feet in silence.

Nothing pleased me more than this silence and this stamping of feet. Our good men quickly began to resemble those insects whose ferocious behavior is only revealed on film. Their dance was an organized accident, false

steps that were extended and alternated with the discipline of a fugue. The inconveniences of moving under these structures, far from weakening the choreography, created the necessity of breaking with old formulas, of searching for inspiration, not from what moves but from what one must move around, from what is shifted according to the rhythms of our march.

During the final rehearsals, when the workmen delivered the poorly made body of the thundering, languid horse, it had been transformed into a cab-horse.... Our uncontrolled laughter and that of the stagehands convinced Picasso to let it keep its accidental shape. Never could we have guessed that the audience would take so badly one of the few concessions we made.

There remain the three parade characters, or more exactly, the four of them, because I transformed the acrobat into a pair, allowing Massine to set a parody of an Italian pas-de-deux alongside our experiments in realistic ordering.

Contrary to what the public thinks, these characters are more linked to the Cubist school than our Managers are. The Managers are scenery, Picasso portraits that move, and their structure imposes a certain choreographic approach upon them. As for the four characters, it was a matter of taking a sequence of actual movements and transposing these into dance without losing a realist force, just as a modern painting is inspired by real objects transposed into painting without however letting them lose the power of their volume, matter, color, and shadows....

Jean Cocteau,
Le Coq et l'Arlequin (The Rooster and the Harlequin), 1918

Picasso and Ceramics

The ancient art of ceramics allowed Picasso to combine his gifts in sculpture and painting. In 1946 an encounter with Georges Ramié and his wife, Suzanne, who ran a ceramics studio called Madoura in Vallauris, prompted Picasso to explore all the resources of this medium. Here again he experimented, overturning convention after convention. His audacity stupefied his new friends. Regarding his methods, they said "An apprentice who worked like Picasso would never find a job."

W*oman with Mantilla,* ceramic, 1949.

The Ceramics Student

Immediately, thrilling discoveries in a field infinitely vast where an abundance of precepts had already been laid down, then abandoned, then forgotten!... During the centuries that so many seekers had excavated this mystery with avidity and patience, could it be that everything had been said, that all forms of expression had been traced out, all creative possibilities seen the light of day?... Anyway, the multiplicity of ancient processes were, in truth, judged by him to be insufficient: the painter, condemned to the relative exiguity of the canvas and oil, finds himself, doubtlessly, suddenly liberated, faced with this always moving—and, because of this, boundless—space and palette, offered from here on in to his imagination, like a new dimension revealed suddenly....

Can Picasso do what he does simply because he was born Picasso? No doubt, but also because ceaselessly, at every instance, and for years, a new Picasso surges forth from the Picasso of a few moments before. And this vertiginous evolution explains all the diversity of procedures, all the seeming divergence in approach, all the universality of means, all the capacity for expression that is associated with him....

Many art lovers will be surprised perhaps by what he has produced but will also wonder what subtle matter, what unsuspected palette, what unknown texture they are being presented with. And it is not the least of Picasso's achievements to be able to fit the means of another age to the measure of his talent and imagination and to ask, in his turn to others, the question he asks himself and that in

Picasso in Madoura, the Vallauris ceramics studio, during the 1950s.

responding to it, he has surpassed.

Because he has gone beyond it—with his revolutionary suddenness that pushes him not so much to flee worn-out clichés and to reject, by temperament, ready-made ideas, but to seek, without constraint, the natural expansion of his character attracting him toward the unceasing discovery of himself and the universe. From this gushes forth this dynamism—at times disconcerting—this creative power, this volubility exploding like fireworks, and all these lucky finds that surprise, then fascinate, because, acting as metaphors for the end of a state of the soul whose progression evades us, they are likewise propositions of the spirit or secrets.

Picasso's ceramics, presenting all these unforeseen and mysterious qualities, constitute an unforgettable moment of meditation and emotion. And thus, he will have given us, and with a very Spanish charm, a new motivation to teach, to enchant, to admire.

And since it was through an unmerited chance that we were given the perilous honor of teaching our metier to this masterful student and of living and working with him side by side during the long months, let us to render homage to his most touching virtue: What Picasso was able to produce in this craft so new to him he owes certainly to his prodigious genius for invention, to his ongoing need to create, to his ability to immediately adapt—but also to the modesty with which he faces all things: the modesty of the laborer who approaches a fallow field and attacks it with a fervor that gives him the certain hope of fertile harvests.

Georges and Suzanne Ramié
Madoura Workshop
Vallauris, April 1948

Picasso and Bullfighting

Spanish in his soul and his blood, Picasso, like his compatriot Francisco de Goya (1746–1828), was a painter par excellence of the bullfight. As a child, he went with his father to the Málaga arenas, where he drew pictures of his first bullfights. Later, whenever he went to Spain, he would return with paintings depicting the bull, the wounded horse, or the death of the torero.

A n original illustration for the title page of *Picasso: Toros y Toreros.*

Bullfighter at Heart

Picasso is interested in all that I do and feels suspense and anxiety about all my potential successes. Yet he would be happy if I were ever to tell to him that I am retiring from the bullring, and he would even weep were he to hear that I had met my death in the ring: "He has met with his destiny." We bullfighters inflict on all those whom we love great anxieties which, though frequent and repeated, are none the less terrible. But at once we can instinctively distinguish those who approach us as men wearing spangled suits from those others who approach us as human beings, for ourselves. Pablo, for instance, is a bullfighter at heart and can also recognize quite easily those moths who are attracted to him by the light of his fame.

He recognizes at the very first compliment—he who has received hundreds of compliments and homages in his life—any man who comes to him in order to share the crumbs of his immense celebrity and flatters him for his name rather than for his lifework: and there are indeed many people who praise his work without understanding anything about it. Perhaps it is our common desire to withdraw from the limelight of mere popularity that has actually sealed our friendship.

I may in this respect be the only bullfighter who, while fighting in the rings of France, has resisted the temptation of offering a bull in homage as a *brindis* to Picasso. But today I am also the man who spends some hours, too few in my opinion, conversing with him, enjoying his friendship and still refusing to pose for him. It seems to me that if I were to fight even once in the

Picasso at a bullfight in Nîmes, France.

ring for Picasso, or if he were to paint even once for me, we would lose the intimate quality of our friendship and find ourselves reduced to a merely professional level in our relations. I have observed a strange kind of shyness in Picasso when he has shown me some of his recent works. As for me, whenever he has called on me in my hotel room after one of my fights, I have always felt more than shyness, in fact unworthiness. I suppose what I am talking about is *respect*....

In Picasso I have discovered a being who has nothing in common with the stereotyped image of him that is current throughout the world, in fact as human as anybody else we see as we wander in the streets of a city....

This is the essence of our friendship, which has become mature and intimate, with all the human-ness that fame tries to strip from famous men. Only when a man feels that he is being truly himself,

only when we cease to exhibit ourselves in the terrifying showcase that our profession has become for us, can we at least feel ourselves really at ease. In such moments I have felt communicated to me the thrill, the *duende,* that Picasso's personality inspires in me. As to our familiar address with one another, there is the best of reasons: our friendship.

Art has never had an age, and those who create it are ageless too....

Now I know why I chose to wear my spangled suit of light—probably in order to seek this ultimate purpose that transcends all others. If bullfighters, in choosing their traditional costume, have managed to inspire such artists as Goya and Picasso, they can rest content, having accomplished an important mission. We need no further explana-tions, no more whys and wherefores. It's enough in itself, all that we need.

Luis Miguel Dominguin
Picasso: Toros y Toreros, 1951

Picasso and Politics

Picasso was revolutionary not only in his art, but also in his life and political ideas. He responded in his own way to the tragic events that shook the 20th century, always fighting on the side of freedom. The wrenching drama of the Spanish Civil War (1936–9) found expression in Guernica, *which became one of the most celebrated paintings of the century. During the Second World War, when a Nazi officer was shown a reproduction of* Guernica, *he demanded of Picasso, "Is that you who did that?" Picasso replied, "No, it is you!"*

The Guernica Affair

In May 1937, while he was painting *Guernica,* Picasso stated his sentiments in a communiqué that was printed on posters made in New York in support of the Spanish Republicans. Some time earlier, a rumor had circulated that Picasso was a follower of Franco. He responded in the following terms: "The war in Spain represents the battle of reactionary forces against the people, against freedom. My entire life as an artist has been nothing but a daily fight against reactionaries and against the death of art. How could anyone believe for an instant that I would be allied with reactionaries and with death?… In the painting I am working on at this time and which I will call *Guernica,* and in all my recent works of art, I have clearly expressed my horror of the military group that has plunged Spain into an ocean of pain and death.…"

Membership in the Communist Party

In October 1944 the front page of the newspaper *L'Humanité,* a Communist party daily, announced that Pablo Picasso had joined the party. The news caused an uproar. Paris had been liberated only a month earlier. To the numerous American journalists who came to his studio in the Rue des Grands Augustins, he stated:

"My membership in the Communist party is part of the logical progression of my life, of my work. Because, I am proud to say, I have never considered painting as a mere art of adornment, of entertainment; through drawing and

Detail of a poster design for the Second World Peace Congress, in 1950.

VISIONS DE GUERNICA EN FLAMMES
A Galdacano 22 trimoteurs allemands ont mitraillé la population

Un de nos photographes vient de rentrer de Guernica avec ces photographies qui montrent la ville historique en flammes et un vieillard de 81 ans que les bombes ont blessé. On lira dans la page 3 le récit de notre reporter photographe, les informations et les dépêches de notre envoyé spécial Mathieu Corman

Front page of the newspaper *Ce Soir,* 1 May 1937, describing the bombing of Guernica.

color, because these are my weapons, I have wanted to push the knowledge of the world and of humankind a little further forward in order that this knowledge might free us a little more each day; I have tried to say, in my own way, what I considered to be the truest, most accurate, and best, which naturally always means the most beautiful, as the greatest artists know well.

"Yes, I am conscious of having always fought for my painting, as a true revolutionary. But I now understand that that is not enough; these terrible years of oppression have shown me that I must fight not only through my art, but with all of myself....

"Thus, I approached the Communist party without the least hesitation because at base I have always been part of it. Aragon, Eluard, Cassou, Fougeron, all my friends know this well; if I have not officially been a member, it is due to a sort of "innocence," because I believed that my work, my emotional connection would be sufficient, but it was already my own party. Was it not the Communists who worked hardest to know and to build the world, to make the people of today and tomorrow clearer, freer, happier? Was it not they who were the most courageous in France as in the U.S.S.R. or my own Spain? How could I hesitate? From a fear of involvement? But I have never felt myself to be more free, on the contrary, I am more complete! And then, I have been in such haste to find a country: I have always been an

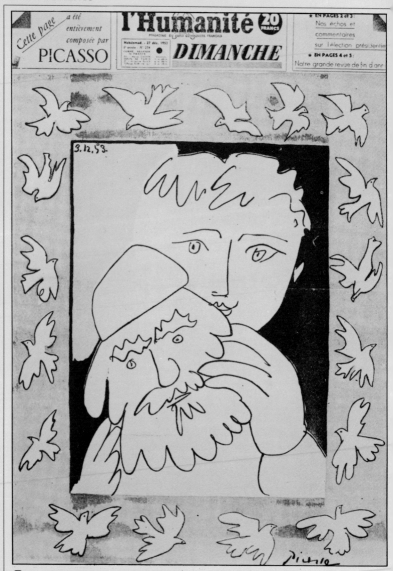

Illustration for the front page of *L'Humanité*, 27 December 1953.

STALINE
et la
FRANCE
par ARAGON

T his portrait of Stalin created by Picasso in 1953 was at the core of a dispute within the French Communist party: Its style was thought to be too fanciful.

exile, now I am no longer; while waiting for Spain to be able finally to welcome me back, the French Communist party has opened its arms to me, and I have found in it everything I respect the most, the greatest thinkers, the greatest poets, the faces, so handsome, of all these Parisian insurgents that I saw during the days of August, I am once again among my brothers!"

An Instrument of War

"What do you think artists are? Imbeciles that have only eyes if painters, ears if musicians, or lyres for all the levels of the heart if poets, or, if boxers, only muscles? Quite to the contrary, they are also political beings, always vigilant before the heartrending, burning, or sweet events of the world, fashioning every part to their own image. How could it be possible to be uninterested in others, and, by virtue of what ivory-tower indifference, to be detached from the life they bring you in such abundance? No, painting is not done to decorate apartments. It is an offensive and defensive instrument of war against the enemy."

Simone Téry,
Les Lettres Françaises
(an underground newspaper of the
French Resistance during
World War II), 24 March 1945

Photo Album

As both a private and a public figure, Picasso was immortalized by some of the greatest photographers of his time, including Brassaï, Dora Maar, and Man Ray. These are less well known photographs taken by friends and family.

Picasso in Barcelona in 1906.

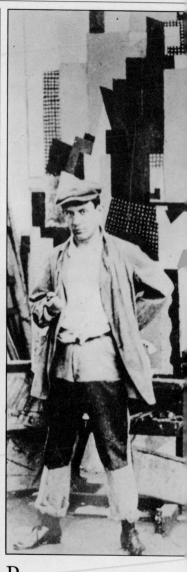

Picasso in 1916.

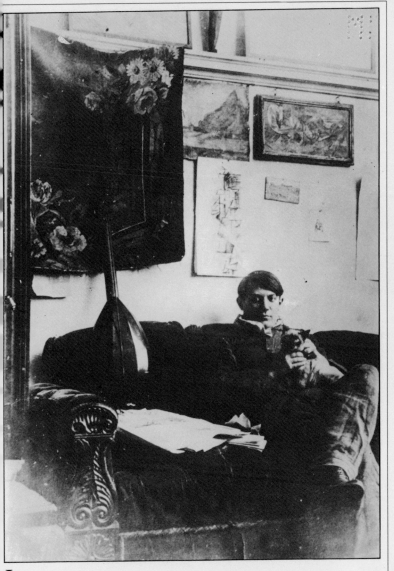

In his studio on the Boulevard de Clichy, around 1910.

With his dog Kasbec on the beach at Golfe Juan.

Paulo on a donkey in 1923.

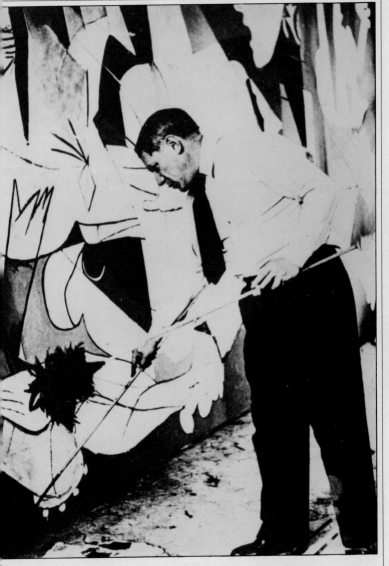

Picasso painting *Guernica* in his studio on the Rue des Grands-Augustins in 1937.

P icasso presiding over a bullfight in Nîmes. To his left, Jean Cocteau; to his right, Jacqueline Roque. Behind him, Paloma, Maïa, and Claude.

Two pictures of Picasso at home in La Galloise in 1951.

Picasso and Claude on the beach at Golfe Juan.

A drawing lesson for Claude and Paloma in Vallauris.

icasso and Jacqueline at La Californie in 1967.

Picasso's Places

Picasso was a wanderer, but a sedentary one. He loved to travel, but he also loved houses. From Málaga to Notre-Dame-de-Vie, by way of the Bateau-Lavoir and Vauvenargues, here are Picasso's home bases, or, if you prefer, his points of departure.

R ue des Grands-Augustins studio on the Left Bank, in Paris (below and right).

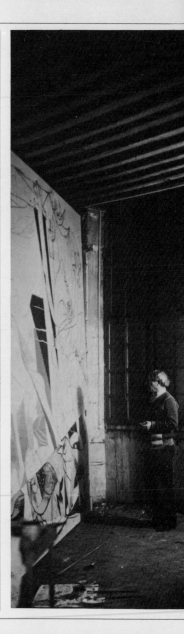

Picasso's birthplace, in Málaga.

Delcros house, in Céret.

Boisgeloup château, in Val-d'Oise.

Studio at Tremblay-sur-Mauldre, near Versailles.

Drawing of La Galloise, on the hillside above the town of Vallauris.

Madoura ceramics studio, in Vallauris.

Château de Vauvenargues, in "Cézanne country."

Notre-Dame-de-Vie, in Mougins.

La Californie, in Cannes.

Above: Bateau-Lavoir, in Montmartre. Right: Rue Schoelcher studio, in Paris.

Boulevard Raspail studio, near Montparnasse.

Picasso's Museums

There are three museums devoted exclusively to Picasso, and hundreds of his works are divided among the other major museums of the world. Once the most productive painter alive, now Picasso is incontestably the most admired painter on the planet.

VILLE D'ANTIBES
MUSEE PICASSO

CHATEAU GRIMALDI
O66OO ANTIBES
TEL.16/93/33.67.67

The Museo Picasso in Barcelona

With its 3000 drawings, lithographs, engravings, and sculptures donated by his friend Jaime Sabartés and by Picasso himself, this museum has a biographical function. Situated near Barcelona's old town, the museum is housed in a splendid 15th-century palace.

As a child, Picasso lived for a time in Barcelona with his family. There, he studied at the Barcelona School of Fine Arts before moving to Paris in 1901.

The museum's works are arranged in chronological order. A tour through the sumptuous halls starts off with a drawing done in 1890, at age nine. Besides many youthful works, there are Blue and Rose period paintings and the variations on Velázquez's *Las Meninas* made in the 1950s.

The Antibes Musée Picasso

In 1946 Picasso met Romuald Dor de la Souchère, curator of the Antibes museum. While visiting Picasso to ask him if he would donate a drawing to the museum, De la Souchère suggested that he use the upper floor of the museum as a studio. The next day Picasso visited the premises and left with the keys in the pocket of his shorts. From August to September 1946, Picasso worked uninterruptedly in the large, cool halls. Subsequently, he came back regularly to visit "his" museum. Toward the end of his life, Picasso asked De la Souchère, "Why not call it the Musée Picasso?" Since then, each year 100,000 visitors from around the world come to see the Antibes Musée Picasso.

The Musée Picasso in Paris

Located in the Hôtel Salé, a splendid 17th-century private mansion in one of

the oldest areas of Paris, the Musée Picasso opened on 28 September 1985.

The collection comprises 203 paintings, 158 sculptures, 16 papiers collés, 88 ceramics, and more than 3000 drawings and prints. These works belonged to Picasso, and after his death they were donated to the French government. The museum also houses treasures from his personal collection, including masterpieces by Cézanne, Matisse, Rousseau, Braque, and Renoir.

Only about 32,000 square feet in size, the museum is smaller than, say, the Louvre, the Tate Gallery, or the Metropolitan Museum of Art. But it numbers among the most invaluable museums in the world.

Interior view of the Musée Picasso in Paris.

Chronology

Picasso's Life	Historical Events
1881 Birth of Pablo Ruiz y Picasso in Málaga	First cabaret, Le Chat Noir, opens in Paris
1891 Father appointed drawing professor at art school in La Coruña	
1895 Accepted into the senior course at the School of Fine Arts in Barcelona	Invention of the motion-picture camera
1897 Studies at the Royal Academy of San Fernando in Madrid	
1898 Visits Horta de San Juan with Manuel Pallarès	
1899 Meets Carlos Casagemas. Meets Jaime Sabartés	French army officer Alfred Dreyfus pardoned
1900 First exhibition (at Els Quatre Gats). First trip to Paris	Discovery of Minoan culture on Crete
1901 Beginning of Blue Period. Exhibition at Ambroise Vollard's gallery in Paris. Meets Max Jacob. Travels to Barcelona and Paris	Death of Henri de Toulouse-Lautrec
1902 Travels to Barcelona and Paris. Shares room with Max Jacob in Paris	
1903 Returns to Barcelona	Death of Paul Gauguin. Wright brothers make first successful flight
1904 End of Blue Period. Moves into the Bateau-Lavoir in Montmartre. Meets Guillaume Apollinaire. Begins relationship with Fernande Olivier. Beginning of Rose Period	Socialist newspaper *L'Humanité* founded in Paris
1905 Meets Gertrude and Leo Stein	Albert Einstein formulates his theory of relativity. Sigmund Freud's *Three Contributions on the Sexual Theory*
1906 Vollard buys many Rose Period canvases. Travels to Gosol, Spain. Introduced to Henri Matisse by Gertrude Stein. *Portrait of Gertrude Stein.* End of Rose Period. Meets André Derain	Death of Paul Cézanne
1907 Discovers African sculpture. *Les Demoiselles d'Avignon.* Meets Daniel-Henry Kahnweiler, who becomes Picasso's dealer. Meets Georges Braque	Beginning of Analytic Cubism. Cézanne retrospective at the Salon d'Automne. Kahnweiler opens Paris gallery
1909 Summer at Horta de San Juan with Fernande. First Cubist landscapes. Moves to Boulevard de Clichy	
1910 *Portrait of Vollard.* Meets Fernand Léger	Death of Henri ("le Douanier") Rousseau

Picasso's Life	Historical Events

1911
Begins relationship with Marcelle Humbert (Eva). Close collaboration with Georges Braque. First exhibition in the United States (Photo-Secession Gallery, New York)

Roald Amundsen reaches the South Pole

1912
Moves to Montparnasse. Braque's first papier collé. Picasso's first papiers collés, collages, and constructions

1913
Death of Picasso's father. Summer in Céret. Moves to Rue Schoelcher

Apollinaire's *Cubist Painters.* Marcel Proust's *Remembrance of Things Past*

1914
Kahnweiler publishes Max Jacob's *The Siege of Jerusalem,* illustrated by Picasso

Beginning of World War I. Apollinaire, Braque, and Derain leave Paris for the front

1915
Max Jacob baptized and Picasso appointed his godfather. Meets Jean Cocteau. Death of Eva

1916
Moves to Montrouge, a Paris suburb. Meets Sergey Diaghilev. Agrees to work on design for the ballet *Parade*

Battle of Verdun. Apollinaire wounded

1917
Leaves for Rome to design sets and costumes for *Parade.* Meets Olga Kokhlova. Sees ancient and Renaissance art. Meets Igor Stravinsky. *Parade* premieres in Paris

Death of Edgar Degas. Death of Auguste Rodin. Revolution in Russia

1918
Chooses new dealer, Paul Rosenberg. Marries Olga

Death of Guillaume Apollinaire. Armistice signed

1921
Birth of Paulo, son of Olga and Picasso. *The Three Musicians*

Adolf Hitler becomes head of Nazi party

1924
Premiere of ballet *Mercure;* set design by Picasso

Publication of André Breton's Surrealist manifesto. First issue of *La Révolution Surréaliste*

1925
Completion of *The Dance.* Breton publishes a reproduction of *Les Demoiselles d'Avignon* in *La Révolution Surréaliste*

First Surrealist exhibition, at the Galerie Pierre in Paris. Death of Erik Satie.

1926
Meets *Cahiers d'Art* publisher Christian Zervos. Guitar series

Death of Claude Monet

1927
Meets Marie-Thérèse Walter

Death of Juan Gris. First talkie, *The Jazz Singer,* released

1929
Meets Salvador Dali

New York Stock Exchange collapses. Museum of Modern Art opens in New York

1930
Buys Château du Boisgeloup

1931
Publication of Ovid's *Metamorphoses* illustrated by Picasso

Picasso's Life	Historical Events			
1935 Olga and Picasso separate. Birth of Picasso and Marie-Thérèse's daughter, Maïa (Maria de la Concepción). Close friendship with Paul Eluard begins. *Minotauromachy*	Croix de Feu (fascist organization) founded in France	**1943** Meets Françoise Gilot. Gestapo searches Picasso's studio. *Man with a Sheep*	Jean-Paul Sartre's *Being and Nothingness*	
1936 Picasso's poems published in *Cahiers d'Art*. Stays in Mougins. Meets Dora Maar. Named director of the Prado	Beginning of Spanish Civil War	**1944** Joins the French Communist party	Death of Max Jacob in a concentration camp. D-Day in Normandy. Paris liberated. Death of Wassily Kandinsky	
1937 Moves to new studio on the Rue des Grands-Augustins. Publishes *The Dream and Lie of Franco*. *Guernica* exhibited in the Spanish pavilion at the International Exhibition in Paris	Guernica bombed by Germans on 26 April	**1945** First lithographs in Fernand Mourlot's studio	Germany surrenders	
		1946 Picasso retrospective at the Museum of Modern Art, New York. Moves studio into the museum in Antibes	Death of Gertrude Stein	
1939 Death of Picasso's mother. *Night Fishing at Antibes*	Death of Ambroise Vollard. General Franco captures Barcelona. Hitler invades Poland	**1947** Birth of Picasso and Françoise's son, Claude. First ceramics at Vallauris	Death of Paul Rosenberg	
		1948 Moves to La Galloise in Vallauris		
1940 Moves into studio on the Rue des Grands-Augustins for duration of the war	German occupation of Paris. Death of Paul Klee	**1949** *The Dove* chosen as symbol of the World Peace Congress. Birth of Paloma, second child of Picasso and Françoise	People's Republic of China founded	
1941 *Desire Caught by the Tail*	United States enters World War II	**1950** Awarded the Lenin Peace Prize	Beginning of the Korean War	
		1951 *Massacre in Korea*		
1942 Publication of Comte de Buffon's *Histoire Naturelle* illustrated by Picasso		**1952** *War* and *Peace*. *Four Little Girls*	Samuel Beckett's *Waiting for Godot*. Death of Paul Eluard	

Picasso's Life	Historical Events	Picasso's Life	Historical Events
1953 Controversial portrait of Joseph Stalin printed in *Les Lettres Françaises*. Françoise and Picasso separate	Death of Joseph Stalin	**1959** Begins variations on Manet's *Déjeuner sur l'Herbe*	André Malraux becomes French Minister of Culture
1954 Meets Jacqueline Roque at the Madoura ceramics studio in Vallauris. Begins variations on Delacroix's *Women of Algiers*	Death of Henri Matisse	**1961** Marries Jacqueline. Moves to Notre-Dame-de-Vie, at Mougins. Picasso's eightieth birthday celebrated in Vallauris. Variations on Manet's *Déjeuner sur l'Herbe*	First person in space (Yuri Gagarin, of the former U.S.S.R.)
1955 Death of Olga Kokhlova. Buys La Californie in Cannes. Picasso retrospective in Paris. Henri-Georges Clouzot films *Le Mystère Picasso*. *Portrait of Jacqueline in Turkish Dress*	Former U.S.S.R. declares end of war with Germany. Winston Churchill resigns as prime minister of Great Britain	**1962** Awarded Lenin Peace Prize for the second time. Produces seventy *Jacquelines* (paintings, drawings, engravings, and ceramic tiles)	
		1963 The Painter and His Model series	Opening of the Barcelona Museo Picasso. Death of Georges Braque. Death of Jean Cocteau. John F. Kennedy assassinated
1956 *Two Women on the Beach*. Picasso and nine other artists and intellectuals express concern about the Soviet invasion of Hungary in a letter to the Central Committee of the French Communist party	United Nations General Assembly censures the former U.S.S.R. Martin Luther King emerges as civil rights leader	**1966** Worldwide celebration of Picasso's eighty-fifth birthday. Picasso retrospective in Paris	Cultural Revolution in China. Death of André Breton
1957 Begins variations on Velázquez's *Las Meninas*. Picasso 75th Anniversary Exhibition in New York, Chicago, and Philadelphia	International Atomic Energy Agency established. Jack Kerouac's *On the Road*	**1968** Death of Jaime Sabartés. Picasso donates the *Las Meninas* series and a Blue Period portrait of Sabartés to the Museo Picasso in Barcelona as a tribute to Sabartés	Student uprisings in Paris. Occupation of Czechoslovakia by Soviet troops
1958 Buys Château de Vauvenargues, near Aix-en-Provence. Works on mural for the new UNESCO building in Paris		**1970** Picasso donates nearly all his early work to the Museo Picasso in Barcelona	Death of Christian Zervos
		1973 Death of Picasso at Notre-Dame-de-Vie	

Further Reading

Apollinaire, Guillaume, *The Cubist Painters,* Wittenborn, New York, 1946

Barr, Alfred H., Jr., *Picasso: Fifty Years of His Art,* The Museum of Modern Art, 1946

Berger, John, *The Success and Failure of Picasso* (rev. ed.), Pantheon, New York, 1989

Bernadac, Marie-Laure, and Christine Piot, eds., *Picasso: Collected Writings,* Abbeville, New York, 1993

Besnard-Bernadac, Marie-Laure, et al., *The Picasso Museum, Paris,* Abrams, 1986

Boggs, Jean Sutherland, *Picasso and Things: The Still Lifes of Picasso,* Rizzoli, New York, 1992

Brassaï, *Picasso and Company,* Doubleday, Garden City, New Jersey, 1966

Cabane, Pierre, *Pablo Picasso: His Life and Times,* Morrow, New York, 1977

Cooper, Douglas, *Picasso Theatre,* Abrams, New York, 1987

Daix, Pierre, *Picasso,* Praeger, New York, 1965

Daix, Pierre, and Joan Rosselet, *Picasso: The Cubist Years, 1907–1916,*

A Catalogue Raisonné of Paintings and Related Works, New York Graphic Society, Boston, 1979

Daix, Pierre, Georges Boudaille, and Joan Rosselet, *Picasso: The Blue and Rose Periods, A Catalogue Raisonné of Paintings,* New York Graphic Society, Greenwich, Connecticut, 1966

Dominguin, Luis, and Georges Boudaille, *Picasso: Bulls and Bullfighters,* Abrams, New York, 1961

Duncan, David Douglas, *Picasso's Picassos* (rev. ed.), Ballantine, New York, 1968

Eluard, Paul, *Pablo Picasso,* Philosophical Library, New York, 1947

Gilot, Françoise, *Matisse and Picasso: A Friendship in Art,* Doubleday, New York, 1990

Gilot, Françoise, and Carlton Lake, *Life with Picasso,* Doubleday, New York, 1989

Glimcher, Arnold and Mark, eds., *Je Suis le Cahier: The Sketchbooks of Pablo Picasso,* Pace Gallery, New York, 1986

Kahnweiler, Daniel-Henry, *My Galleries and Painters,* Viking Press, New York, 1971

Malraux, André, *Picasso's Mask,* Holt, Rinehart and Winston, New York, 1976

McCully, Marilyn, ed., *A Picasso Anthology: Documents, Criticism, Reminiscences,* Arts Council of Great Britain, London, 1981

Mourlot, Fernand, *Picasso Lithographe,* vols. 1–3, Editions de Livre, Monte Carlo, 1949, 1950, 1956

O'Brian, Patrick, *Pablo Ruiz Picasso: A Biography,* Putnam, New York, 1976

Palau i Fabre, Josep, *Picasso: The Early Years, 1881–1907,* Rizzoli, New York, 1981

Parmelin, Hélène, *Picasso Says,* A. S. Barnes, South Brunswick, New Jersey, 1969

———, *Picasso: The Artist and His Model,* Abrams, New York, 1968

Penrose, Roland, *Picasso: His Life and Work,* University of California Press, Berkeley, 1981

———, *Portrait of Picasso,* The Museum of Modern Art, New York, 1957

———, *Sculpture of Picasso,* The Museum of Modern Art, New York, 1967

Picasso, Pablo, *Desire: A Play,* Philosophical Library, New York, 1948

Ramié, Georges, *Picasso's Ceramics,* Viking, New York, 1976

Richardson, John, *A Life of Picasso,* vol. 1, Random House, New York, 1991

Rubin, William, *Picasso and Braque: Pioneering Cubism,* The Museum of Modern Art, New York, 1989

Rubin, William, ed., *Pablo Picasso: A Retrospective,* The Museum of Modern Art, New York, 1980

Sabartés, Jaime, *Picasso: An Intimate Portrait,* Prentice-Hall, New York, 1949

Sabartés, Jaime, and Wilhelm Boeck, *Pablo Picasso,* Abrams, New York, 1955

Schiff, Gert, *Picasso: The Last Years, 1963–1973,* Braziller, New York, 1983

Souchère, Romuald Dor de la, *Picasso in Antibes,* Pantheon, New York, 1960

Stassinopoulos, Arianna, *Picasso: Creator and Destroyer,* Simon and Schuster, New York, 1988

Stein, Gertrude, *Picasso,* Dover, New York, 1959

Zervos, Christian, *Picasso, Cahiers d'Art,* 33 vols., Paris, 1932–78

List of Illustrations

Index

Acknowledgments

The publishers and the authors would especially like to acknowledge their debt to Roland Penrose and his seminal *Picasso: His Life and Work*. The publishers would also like to thank Jean-Loup Charmet, Laurence Marcillac, Ludovic Beaugendre, Yves de Fontbrune, Calmann-Lévy, Cercle d'Art, *Cahiers d'Art*, *L'Humanité*, and *Les Lettres Françaises*

Photograph Credits

Agence Scala, Florence 49, 51. All rights reserved 28–9, 33 gatefold, 35, 37, 50al, 71, 94a, 103a, 104–5, 119, 121b, 128, 129b, 129a, 133, 139, 140, 141, 146, 150, 151, 152a, 152b, 153, 154, 155, 164, 166, 168, 169, 172a, 173. Archives *Cahiers d'Art*, Paris 52a, 56, 143, 160. Artephot/Ziolo, Paris 30, 31, 32, 55, 59. Bibliothèque de l'Opera, Paris 158, 159. Edimédia, Paris 33 gatefold, 40–1, spine. E.T. Archives, London 48a, 76. Gamma/Quinn, Paris 176b. Gilberte Brassaï 101, 135, 147. Giraudon, Paris 26, 33 gatefold, 34, 43, 58, 61, 116, 118. *L'Humanité*, Paris 167. Magnum/Burri, Paris 107r, 175a, 177. Magnum/Capa, Paris 106–7, 176a. Mas, Barcelona 96 gatefold, 97 gatefold (all). MNAM, Paris 44, 68–9. Musée Picasso, Paris 17b, 19a, 20a, 38, 39, 54, 57, 77a, 88a, 170bl, 172b, 178–9. Museo Picasso, Barcelona 18–9, 25. Photothèque Spadem, Paris 16. Rapho/Doisneau, Paris 126–7, 131, 163, 175b. Rapho/Fouchenault, Paris 165. Rapho/Ronis, Paris 124. RMN, Paris 21, 22r, 22–3, 27, 36, 42, 45, 46, 47, 48b, 50cl, 50bl, 52–3, 62–3, 64ar, 64br, 64bl, 64al, 65, 66, 67, 68, 70, 73, 74–5, 79, 80al, 80ar, 81, 84, 85, 86, 87, 88b, 89, 91a, 93, 94–95, 98–9, 100, 103b, 105, 106a, 108a, 108br, 108bl, 109, 110, 111, 112, 113, 114, 115, 122–3, 125, 156, 157, 162, 170r, 171, 181, back cover, front cover. Roger Viollet, Paris 78, 90–1, 136, 144. Staatgalerie, Stuttgart 82–3. Top/Doisneau, Paris 117, 130. Top/Willi, Paris 20b, 58, 60

Text Credits

Grateful acknowledgment is made for use of material from the following: Brassaï, *Picasso and Company*, translated by Francis Price, Doubleday & Company, Inc. 1966, © Editions Gallimard 1964 (pp. 134–6); Dominguin, Luis Miguel, *Picasso: Toros y Toreros*, translated by Edouard Roditi, Cercle d'Art publishers. Reproduced with permission of the publisher (pp. 164–5); Eluard, Paul, *Pablo Picasso*, translated by Joseph T. Shipley, Philosophical Library, New York, 1947 (pp. 142–5); Gilot, Françoise, and Carlton Lake, *Life with Picasso*, McGraw-Hill, Inc., New York, 1964. Reproduced with permission of McGraw-Hill (pp. 130–1); Kahnweiler, Daniel-Henry, with Francis Crémieux, *My Galleries and Painters*, translated by Helen Weaver, Copyright © 1971 by Thames and Hudson, Ltd. Used by permission of the publisher (pp. 132–3); *Picasso's Mask*, originally titled *La Tête d'Obsidienne de Le Miroir des Limbes (Tome II)*, by André Malraux, English translation by June Guicharnaud with Jacques Guicharnaud. Copyright © 1976 by Editions Gallimard. English translation copyright © 1976 by Henry Holt and Company, Inc. Reprinted by permission of Henry Holt and Company, Inc. 1976 (pp. 136–7); Picasso, Pablo, *Desire: A Play*, translated by Bernard Frechtman, Philosophical Library, New York, 1948 (pp. 146–9); Richardson, John, excerpt from "Picasso: A Retrospective View," in *A Picasso Anthology: Documents, Criticism, Reminiscences*, edited by Marilyn McCully. Text and translations © Arts Council of Great Britain. Reproduced with permission of the author (pp. 140–1); Stein, Gertrude, excerpt from "Picasso" in *A Picasso Anthology: Documents, Criticism, Reminiscences*, edited by Marilyn McCully. Text and translations © Arts Council of Great Britain. Reproduced with permission of the Estate of Gertrude Stein (p. 141)

Marie-Laure Bernadac, born in 1950, is a curator in the graphic arts department of the Paris Musée National d'Art Moderne (the Georges Pompidou Center). Previously she was curator of the Musée Picasso in Paris (1981–92). Bernadac is the author of *Le Musée Picasso* (1985) and coauthor of a catalogue of the Musée Picasso (an English edition, *The Picasso Museum, Paris*, was published in 1986). She is also one of the writers of the film *Picasso*, produced by Didier Baussy in 1986.

Paule de Bouchet, born in 1951, was a journalist for *Okapi*, a children's magazine, from 1978 to 1948. She is the author of numerous books for young people and currently is an editor at Editions Gallimard in Paris.

For Agathe and Yacine

Translated from the French by Carey Lovelace

For Abrams
Project Manager: Sharon AvRutick
Typographic Designer: Elissa Ichiyasu
Assistant Editor: Jennifer Stockman
Design Assistant: Penelope Hardy

Library of Congress Catalog Card Number: 93–70488

ISBN: 978-0-8109-2802-2

ABRAMS
THE ART OF BOOKS SINCE 1949
115 West 18th Street
New York, NY 10011
www.abramsbooks.com